PHOTOSECRETS
LONDON

WHERE TO TAKE PICTURES

BY
ANDREW HUDSON

*"A good photograph
is knowing where to stand."*
— Ansel Adams

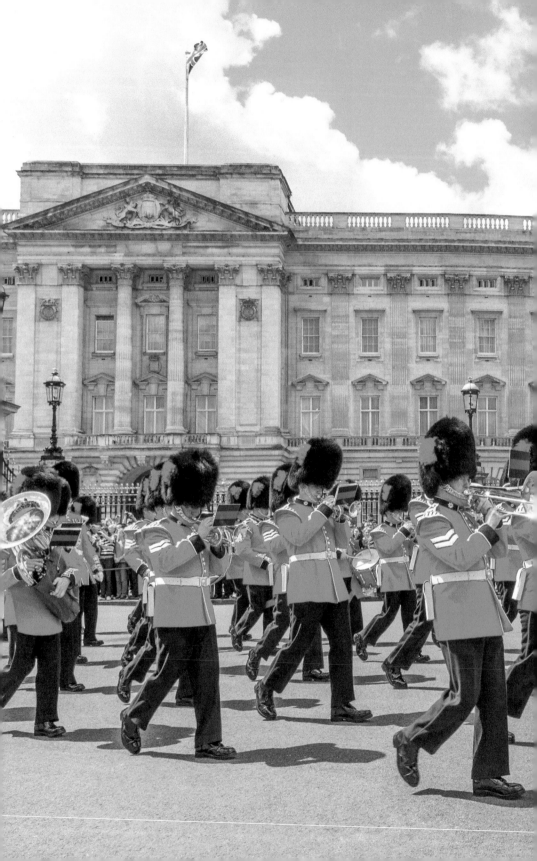

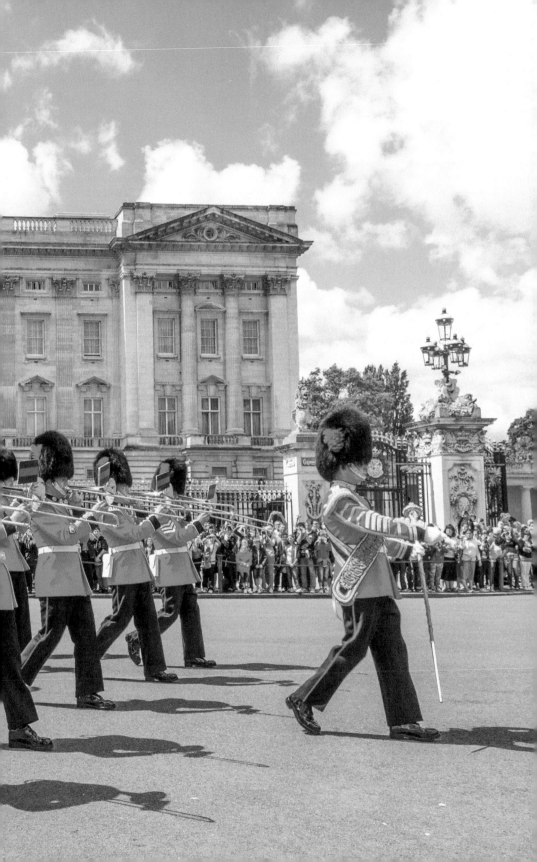

By Andrew Hudson

THANK YOU for reading PhotoSecrets. As a fellow fan of travelling with a camera, I hope this guide will quickly get you to the best spots so you can take postcard-perfect pictures.

PhotoSecrets shows you all the best sights. Look through, see the classic shots, and use them as a departure point for your own creations. Get ideas for composition and interesting viewpoints. See what piques your interest. Know what to shoot, why it's interesting, where to stand, when to go, and how to get great photos.

Now you can spend less time researching and more time photographing.

The idea for PhotoSecrets came during a trip to Thailand, when I tried to find the exotic beach used in the James Bond movie *The Man with the Golden Gun*. None of the guidebooks I had showed the beach, so I thought a travel guide based around postcard photos with maps and descriptions would be useful. Twenty-plus years later, you have this guide, and I hope you find it useful.

Take lots of photos!

Andrew Hudson

Andrew Hudson started PhotoSecrets in 1995 and has published 27 nationally-distributed color photography books. His first book won the Benjamin Franklin Award for Best First Book and his second won the Grand Prize in the National Self-Published Book Awards.

Andrew has photographed assignments for *Macy's, Men's Health* and *Seventeen*, and was a location scout for *Nikon*. His photos and articles have appeared in *National Geographic Traveler, Alaska Airlines, Shutterbug, Where Magazine,* and *Woman's World*.

Born in England, Andrew has a degree in Computer Engineering from the University of Manchester and was previously a telecom and videoconferencing engineer. Andrew and his wife Jennie live with their two kids and two chocolate Labs in San Diego, California.

☕ Contents

📷 Gallery

Morning

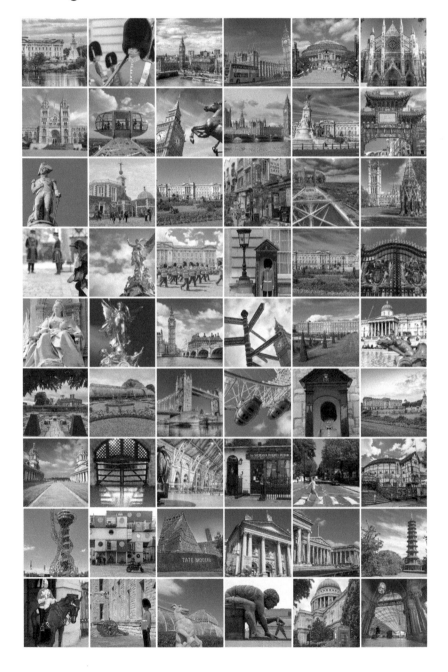

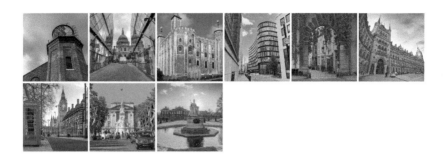

Afternoon

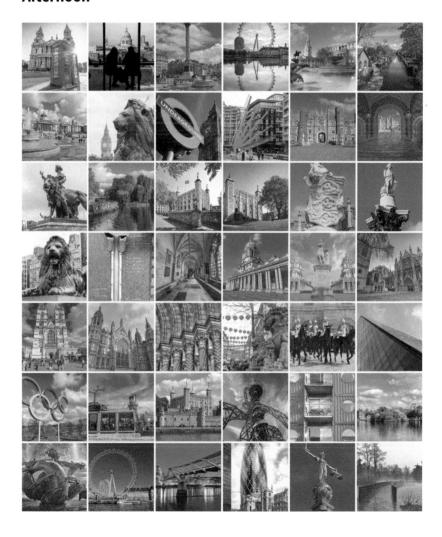

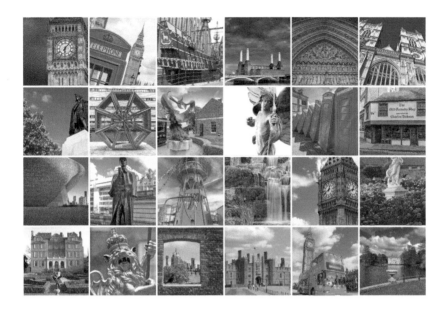

Sunset

Dusk

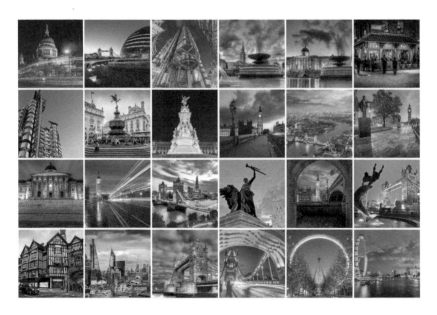

Indoors

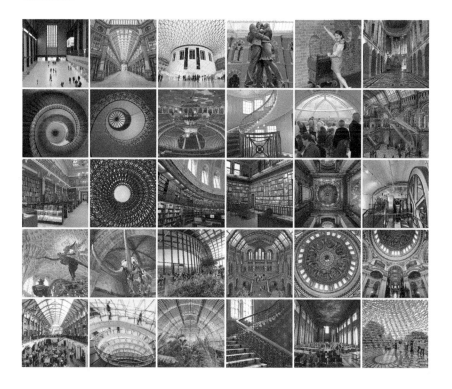

📍 London

London lies in southeast England on the River Thames, which splits Central London into the North Bank and South Bank. Big Ben, Buckingham Palace and other sights are in the City of Westminster.

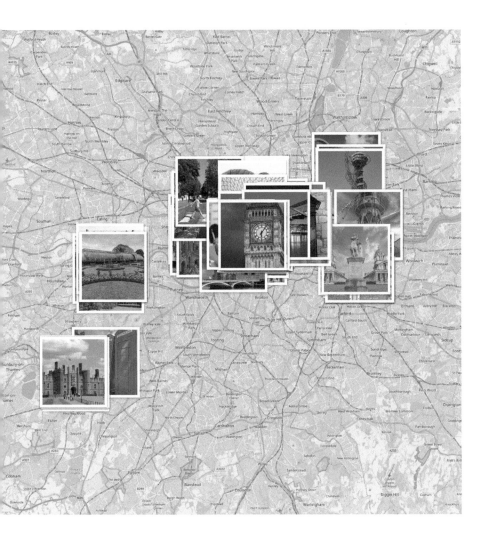

📍 Houses of Parliament

The **Houses of Parliament** (officially the Palace of Westminster) includes Big Ben (officially Elizabeth Tower) which is the icon of London. There are views from both banks of the River Thames.

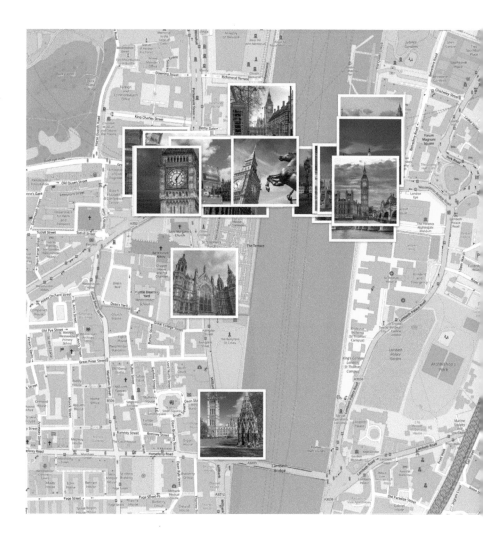

📍 Buckingham Palace

Buckingham Palace is the Queen's London residence and has views from around the entrance. You can photograph the red tunics and black bearskin hats of the Queen's guard.

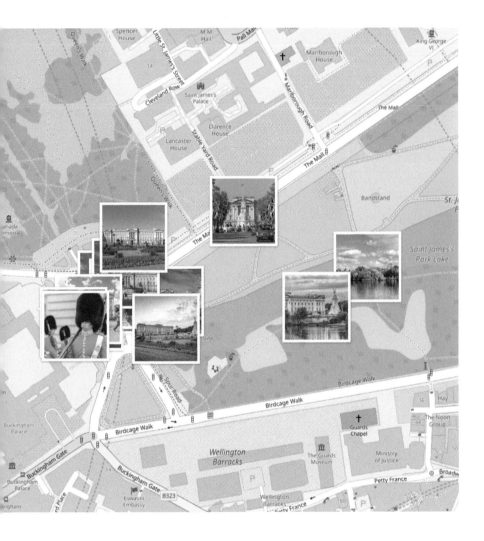

📍 City of Westminster

City of Westminster occupies the official center of London (by Trafalgar Square) and most of the West End, including Covent Garden.

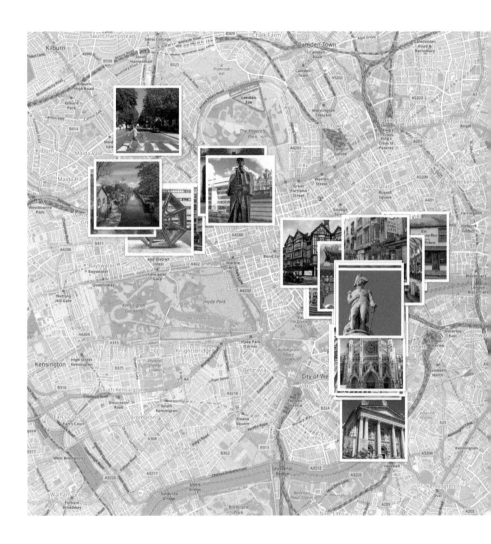

📍 North Bank

The **North Bank** of the River Thames includes the original City of London, now the financial district, and the three most visited attractions: the British Museum, the National Gallery and the Natural History Museum.

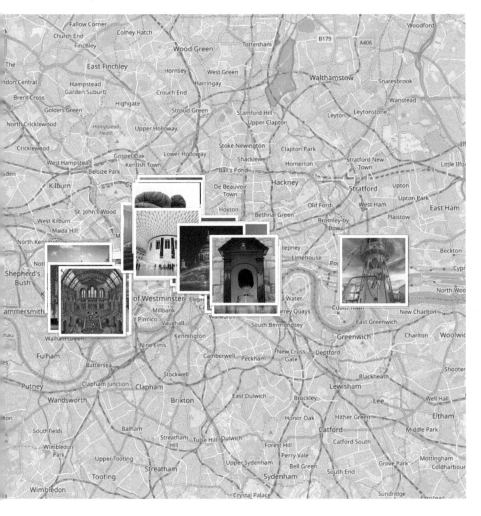

📍 South Bank

The **South Bank** of the River Thames offers the Tate Modern, Millennium Bridge, Shakespeare's Globe, the London Eye, City Hall, and the sights of Greenwich.

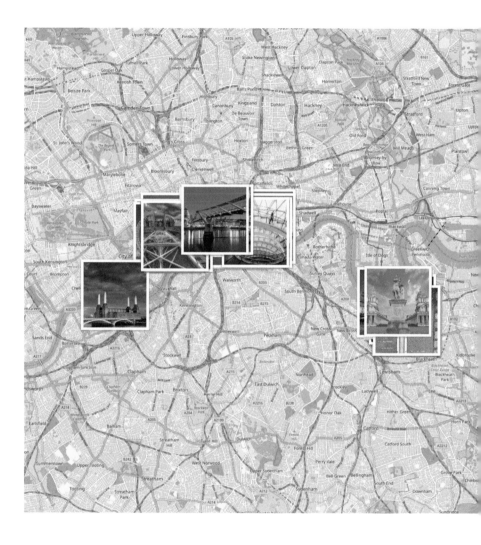

📍 Outer London

Outer London is the name for the group of London Boroughs that form a ring around Inner London, and formally became part of Greater London in 1965. Northeast of Central London is the 2012 Olympic Park; southwest are Hampton Court Palace and Kew Gardens.

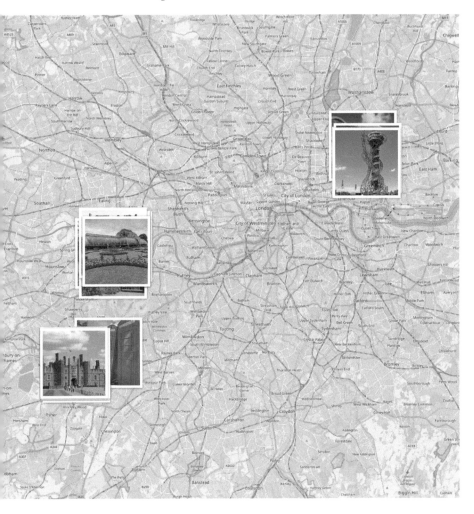

# Foreword By Bob Krist

A GREAT TRAVEL photograph, like a great news photograph, requires you to be in the right place at the right time to capture that special moment. Professional photographers have a short-hand phrase for this: "F8 and be there."

There are countless books that can help you with photographic technique, the "F8" portion of that equation. But until now, there's been little help for the other, more critical portion of that equation, the "be there" part.

To find the right spot, you had to expend lots of time and shoe leather to research the area, walk around, track down every potential viewpoint, see what works, and essentially re-invent the wheel.

In my career as a professional travel photographer, well over half my time on location is spent seeking out the good angles. Andrew Hudson's PhotoSecrets does all that legwork for you, so you can spend your time photographing instead of wandering about. It's like having a professional location scout in your camera bag. I wish I had one of these books for every city I photograph on assignment.

PhotoSecrets can help you capture the most beautiful sights with a minimum of hassle and a maximum of enjoyment. So grab your camera, find your favorite PhotoSecrets spots, and "be there!"

Bob Krist has photographed assignments for *National Geographic, National Geographic Traveler, Travel/Holiday, Smithsonian,* and *Islands.* He won "Travel photographer of the Year" from the Society of American Travel Writers in 1994, 2007, and 2008 and today shoots video as a Sony Artisan Of Imagery.

For *National Geographic,* Bob has led round-the-world tours and a traveling lecture series. His book *In Tuscany* with Frances Mayes spent a month on *The New York Times'* bestseller list and his how-to book *Spirit of Place* was hailed by *American Photographer* magazine as "the best book about travel photography."

After training at the American Conservatory Theater, Bob was a theater actor in Europe and a newspaper photographer in his native New Jersey. The parents of three sons, Bob and his wife Peggy live in New Hope, Pennsylvania.

ℹ Introduction

London beckons your camera with some of Europe's most famous sights: Big Ben, the Queen's Guards and Changing of the Guard, the London Eye, Tower Bridge and the Tower of London.

Located in southeast England on the River Thames, London grew as a port and became the capital and largest city of the United Kingdom.

The Romans founded "Londinium" around AD 43 at a point on the River Thames narrow enough for the construction of a Roman bridge but still deep enough to handle the era's seagoing ships. The site is close to today's London Bridge. Seven Roman roads ran to or from the crossing, making the garrison a commercial hub.

After her lands were annexed, Queen Boudica led British Celtic tribes on a revolt that destroyed Londinium around AD 60. But the port was quickly rebuilt as a planned Roman town on the north bank. There was a forum (near today's St Michael, Cornhill church), baths, an amphitheater and, by 225, a defensive wall. Today, this area is generally the City of London.

The decline and withdrawal of the Roman Empire around 410 saw Londinium abandoned. Activity moved one mile west, around today's Covent Garden, where another port became the Anglo-Saxon settlement of Lundenwic ("London Port"). The newly Christianized Saxon rulers welcomed Mellitus from Italy around 604 and built the first cathedral. This area is today's City of Westminster.

When the Vikings started attacking around 830 onwards, Saxon Alfred the Great refortified the Roman walls and the population moved back to Lundenburg ("London Fort").

Edward the Confessor became king in 1042 and rebuilt the cathedral as the first Westminster Abbey. But he left no heir and his cousin, Duke William of Normandy, claimed the throne. Defeating the Saxons at the Battle of Hastings, William crowned himself King of England in 1066 at Westminster Abbey. He built the Tower of London to subdue Lundenburg, and the Palace of Westminster to become the new political center of England, succeeding the Saxon's Winchester.

By the late 16th century, London increasingly became a major center for banking, international trade and commerce. The Royal Exchange was founded in 1565 and its location on Threadneedle Street is the center of the City's financial district.

In 1666, the Great Fire of London burned for four days and destroyed ¾ of the City within the walls. St Paul's Cathedral was rebuilt

by Christopher Wren and remained the tallest building in London until 1967. Today, the tallest building is The Shard, completed in 2012 at 1,017 feet (310 m).

The 18th century was a period of rapid growth for London, reflecting an increasing national population, the early stirrings of the Industrial Revolution, and London's role at the centre of the evolving British Empire. The urban area expanded beyond the borders of the City of London, most notably during this period towards the West End and Westminster.

Today, over 19 million people visit London, many of them with a camera.

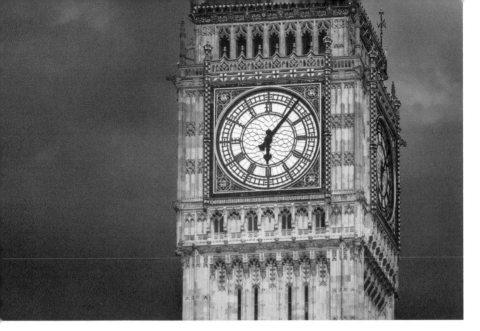

Big Ben is the icon of London and the subject of every establishing shot of the city. So start your photography adventure with pictures that say "I went to London."

Officially called Elizabeth Tower (Big Ben is the nickname of the Great Bell inside), the 315-foot-tall (96 m) Gothic Revival tower was completed in 1856. Located in central London by Westminster tube station, Big Ben is best photographed (as above) in the afternoon from Parliament Square Garden on the west side, with golden light.

You can double your impact with a second icon — a double-decker bus. This shot (right) is from Great George Street at Parliament Street. Using a wide-angle lens increase the perspective for even more impact.

Photographing the iconic sights first allows you to get the essential shots in the bag and let you breathe easier for the rest of the trip.

✉ **Addr:**	Palace of Westminster, London SW1A 0AA	♀ **Where:**	51.5008319 -0.1271486	
❓ **What:**	Tower	☽ **When:**	Afternoon	
👁 **Look:**	East	W **Wik:**	Big_Ben	

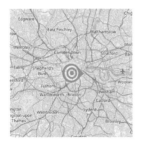
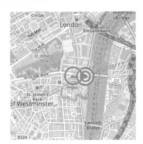
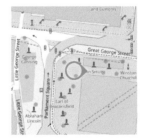

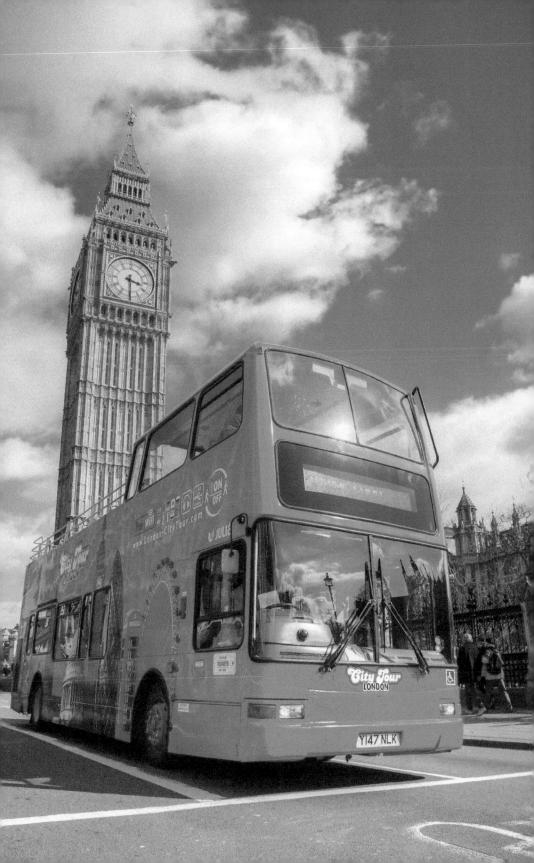

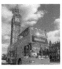
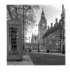

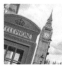
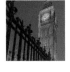

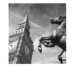

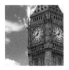

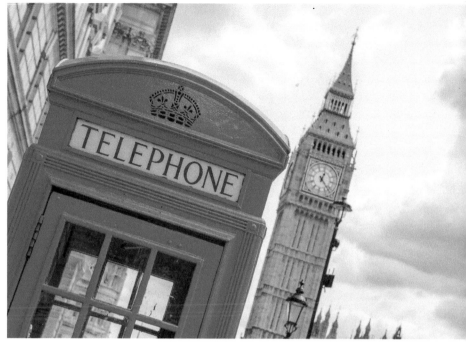

Above: To the west on Great George Street are several red telephone boxes (this is the east one). Note how a slight angle gives the image some dynamic. Below: A pair of boxes to the north on Victoria Embankment await your camera.

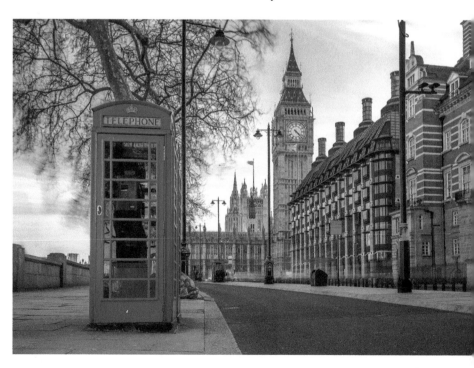

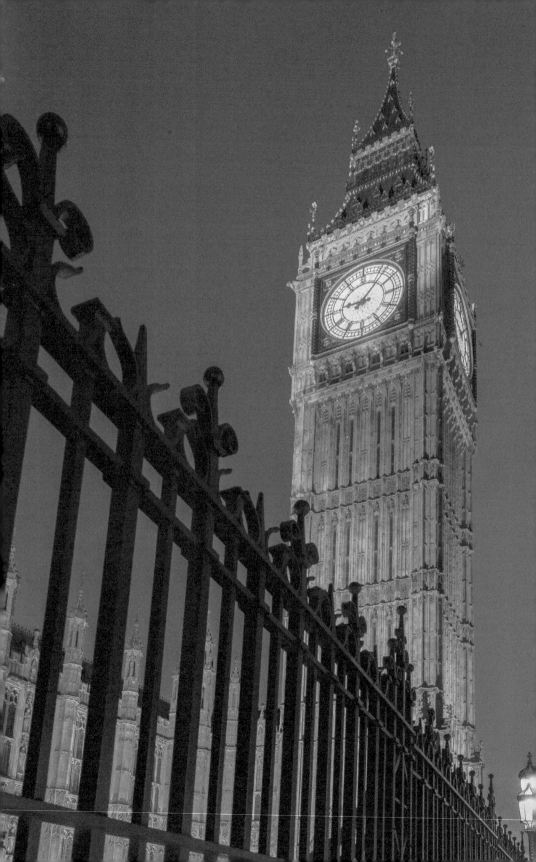

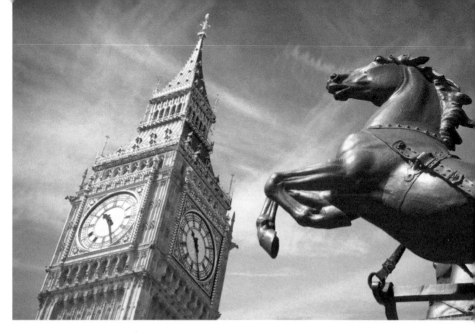

Above: This horse is part of the Boudiccan Rebellion sculpture to the northeast.

 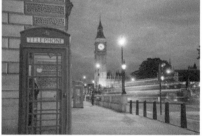

Below: This tube sign is outside Portcullis House, across the street to the north.

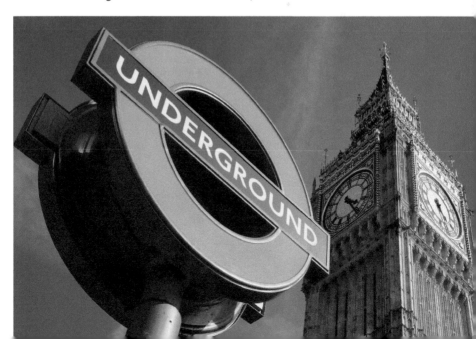

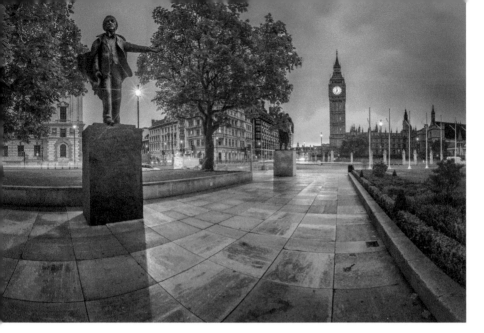

The **Palace of Westminster** includes Big Ben and is known as the Houses of Parliament for its occupants. Replacing a royal palace from 1016 used by the Parliament of England since the 13th century, the current Gothic Revival palace is, for ceremonial purposes, officially a royal residence.

These views are from: Parliament Square Garden (above, west) with a statue of David Lloyd George; Abingdon Street by Old Palace Yard (left, SW); and Victoria Tower Gardens (right, south) with the Buxton Fountain.

✉ **Addr:**	Westminster, London SW1A 0AA	♀ **Where:**	51.500846 -0.126759
❓ **What:**	Capitol	☽ **When:**	Afternoon
👁 **Look:**	East	W **Wik:**	Palace_of_Westminster

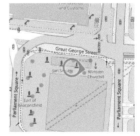

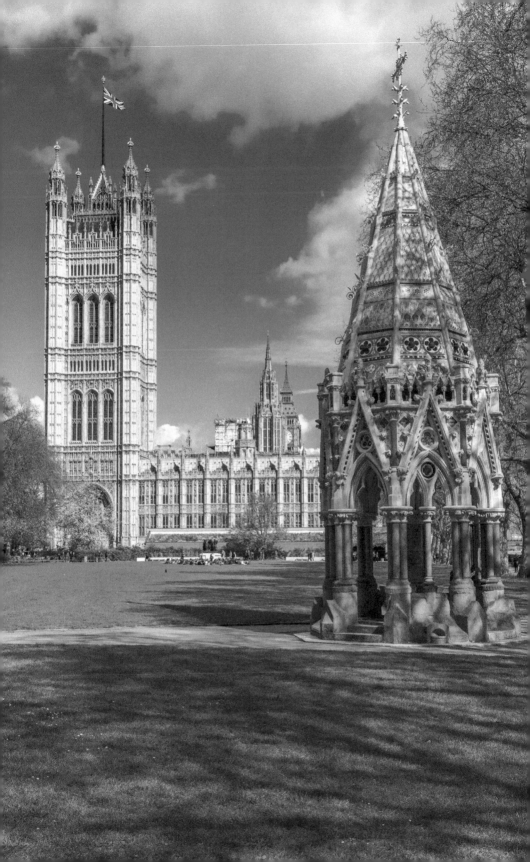

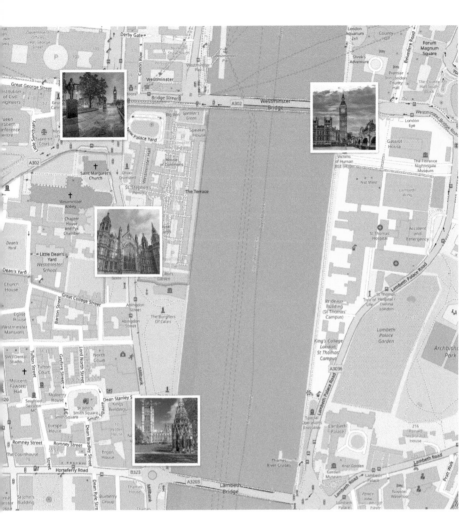

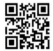
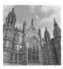

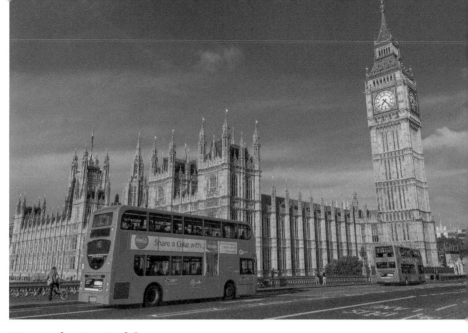

Westminster Bridge and the South Bank provide the classic photos of the Palace of Westminster. Extending east from Big Ben, the bridge is best photographed in the morning (for sunlight from the east) and at dusk. You can include passing buses as a foreground and contrasting color.

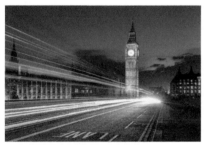

For a shot with tail lights, be on the bridge shortly after sunset, as the light falls during dusk. You'll need a tripod or other steady support to avoid camera blur during the long exposure.

✉ **Addr:**	Westminster Bridge, London SW1A 2JH	♀ **Where:**	51.500881 -0.12041	
❓ **What:**	Bridge	☽ **When:**	Morning	
👁 **Look:**	West	W **Wik:**	Westminster_Bridge	

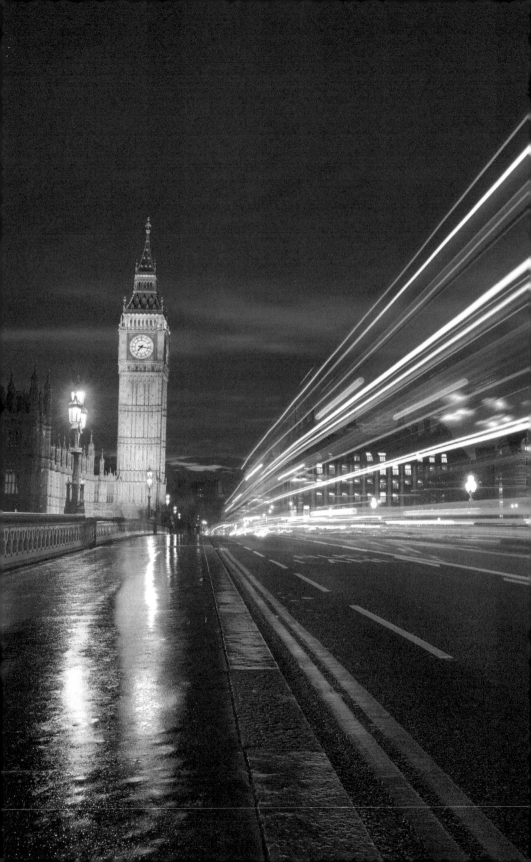

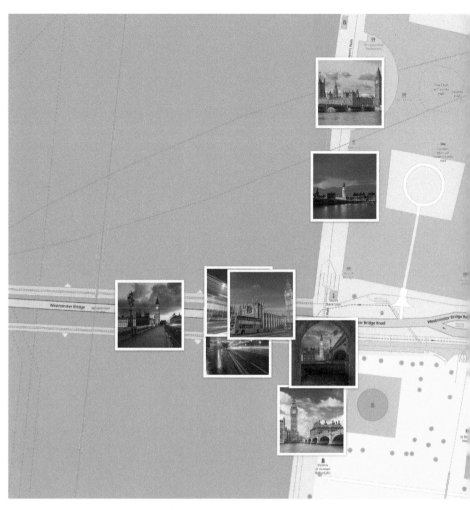

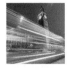

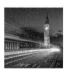
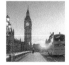
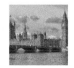

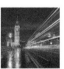

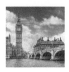

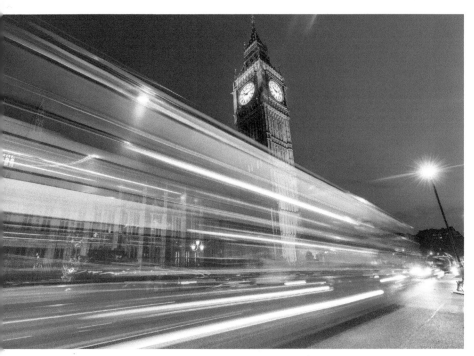

A beautiful arch (right) on the southeast side of the bridge makes a valuable framing device.

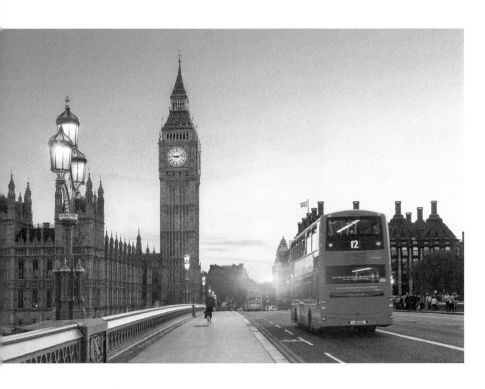

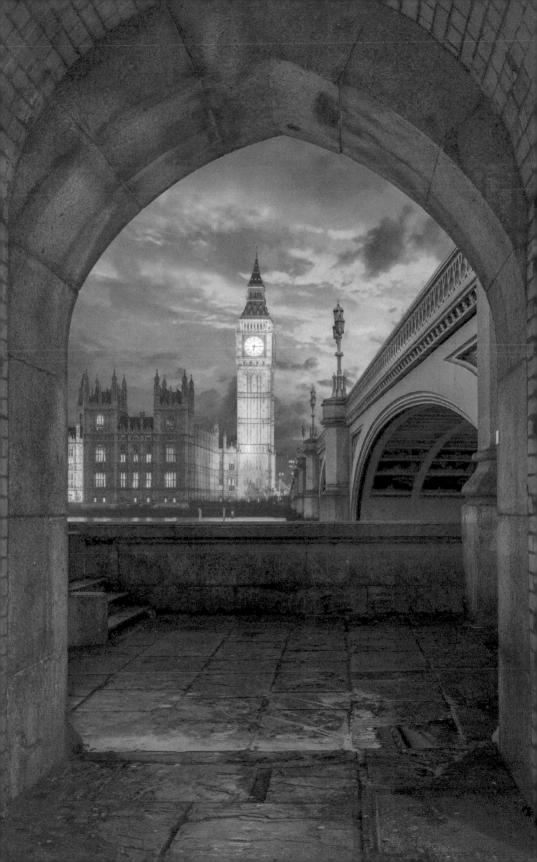

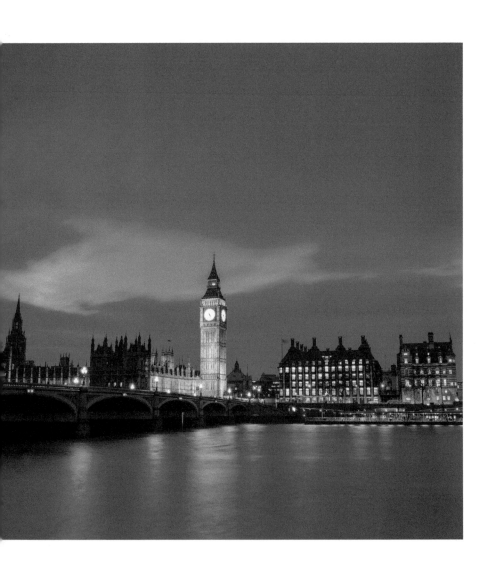

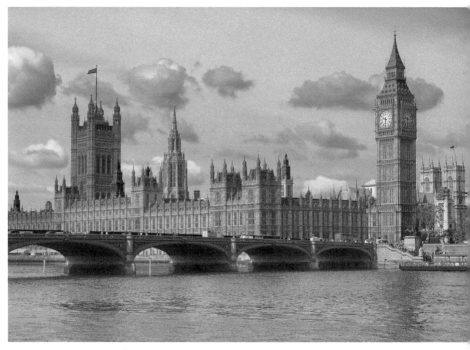

These classic views are from the South Bank (east side), along The Queen's Walk (above:north; below:south).

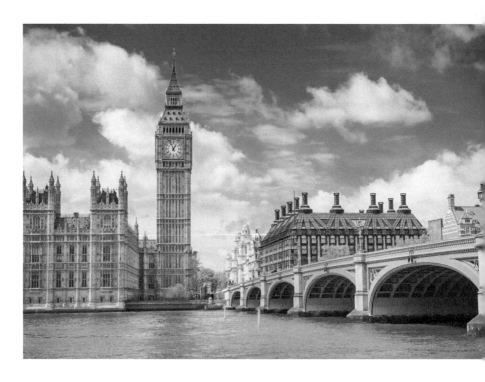

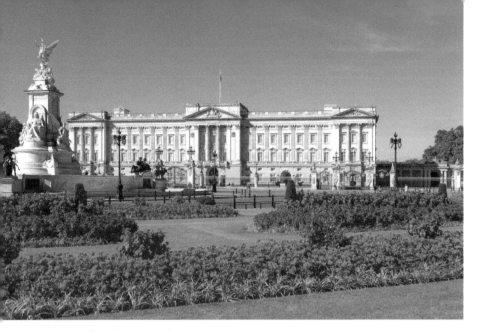

Buckingham Palace is the Queen's London residence and often hosts state occasions and royal hospitality. Dating from 1703 as a townhouse for the Duke of Buckingham, the palace has been enlarged in a French neo-classical style. The principal façade was completed in 1850 by Edward Blore, and redesigned in 1913 by Sir Aston Webb, who also contributed the Victoria Memorial (above).

Located ¾ mile (1.2 km) west of Big Ben, Buckingham Palace is best photographed from the northeast, using as a foreground the flower beds by Green Park (above). Travel photography often has hard, man-made subjects far away, so always look for soft, natural foregrounds to add depth, dimension and color to your shots.

A similar flower bed is on the west side of St James's Park.

✉ **Addr:**	Buckingham Palace, London SW1A 1AA	♥ **Where:**	51.502657 -0.140019
☾ **When:**	Morning	⚆ **Look:**	Southwest
W **Wik:**	Buckingham_Palace	↔ **Far:**	200 m (650 feet)

 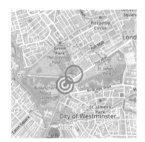

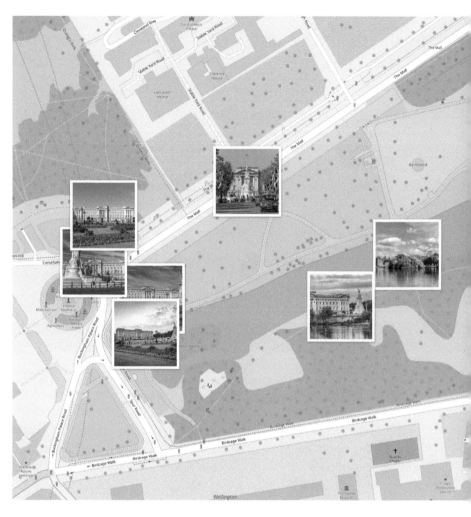

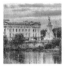

 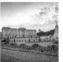 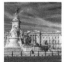

 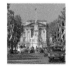

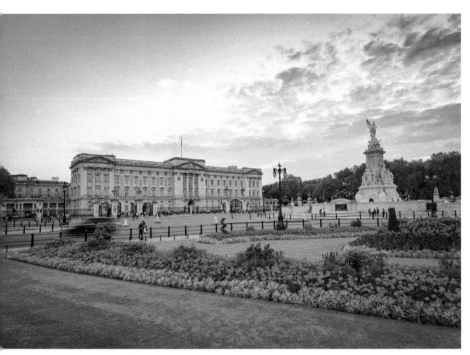

Above: Buckingham Palace and Victoria Memorial from the flower beds in St James's Park. Below: Buckingham Palace became the London residence of the British monarch on the accession of Queen Victoria in 1837.

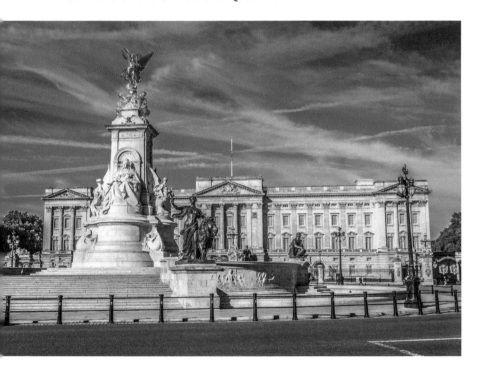

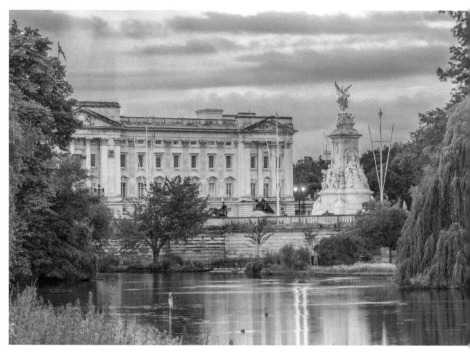

Above: St James's Park Lake and trees give this view a soft, romantic frame.
Below: The Mall is the ceremonial approach.

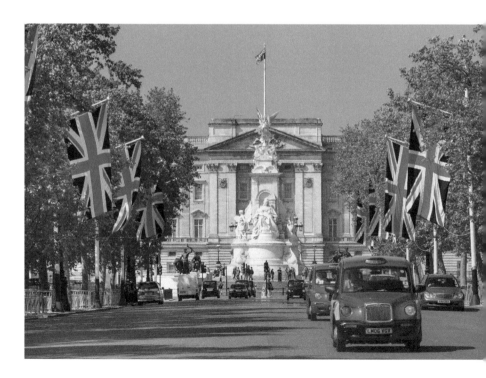

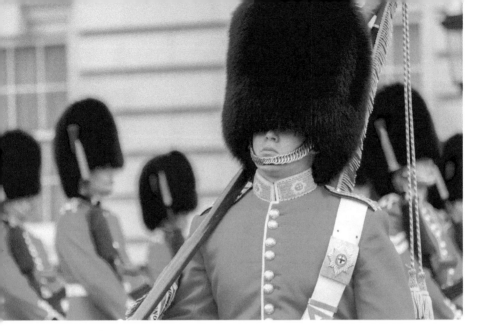

Changing of the Guard is a major ceremony and a perfect time to capture colorful photos of people. This free show features the iconic black bearskin hats and red tunics of The Queen's Guard and occurs once a day in the summer, and every other day otherwise (but not in wet weather or during large events).

The parade starts at 10:45am and is very popular, so arrive well beforehand to claim your preferred spot. I like the west side of the Victoria Memorial, with Buckingham Palace in the background (later page).

At any time, you can photograph a guard outside the east gate (right). Unfortunately you can't get a close-up view as the as you'll be 124 feet (38 m) away, at the fence by the Victoria Memorial. So use a long lens and rest against the ironwork for a steady picture.

✉ **Addr:**	Buckingham Palace, London SW1A 1AA	♀ **Where:**	51.50156 -0.141232	
❷ **What:**	Group	◔ **When:**	Morning	
◉ **Look:**	Southwest	W **Wik:**	Queen%27s_Guard	

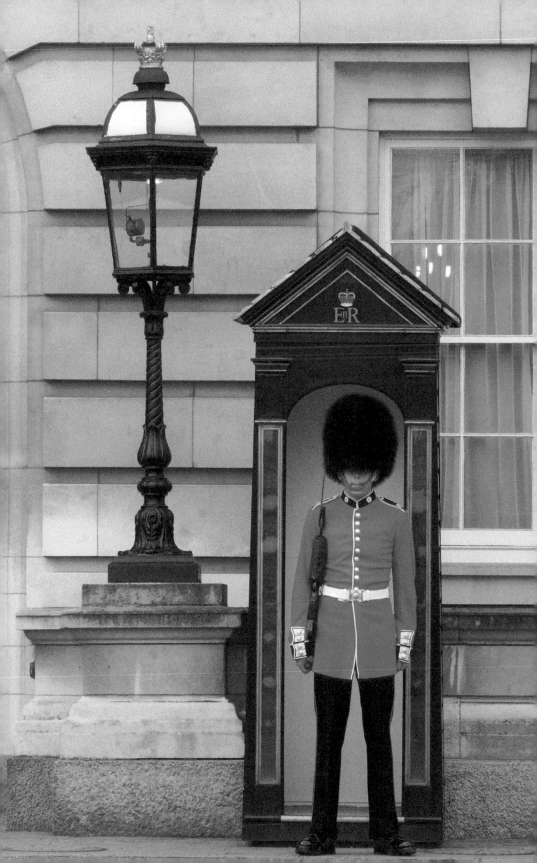

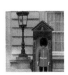

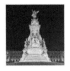

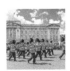

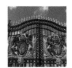

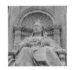

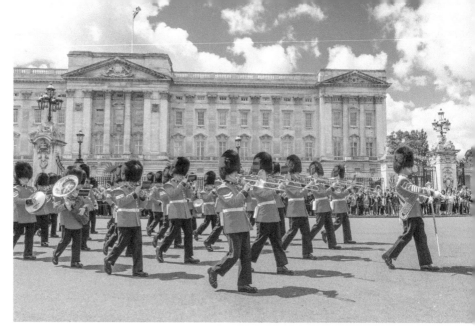

The Coldstream Guards provide musical support during Changing of the Guard.

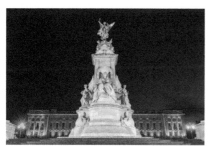

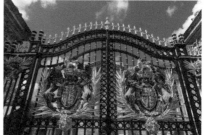

The Victoria Memorial, named for the first monarch to reside here.

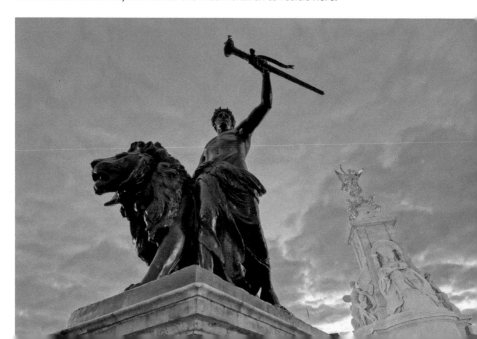

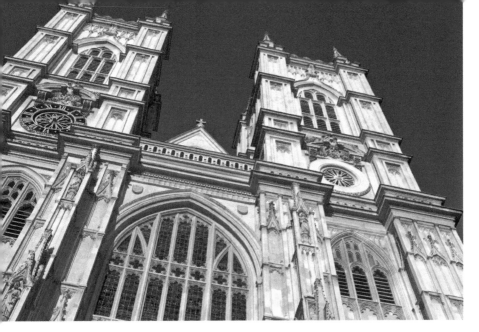

Westminster Abbey has hosted the coronation of every crowned English and British monarch since William the Conqueror in 1016. You may recognize it from the wedding of Prince William and Catherine Middleton in 2011.

A church has existed on the site since the seventh century and the present structure dates from 1245. The mainly Gothic church (which is no longer an abbey) is located next to the Palace of Westminster. There are two sides to photograph: the main entrance on the west side (above) and the north entrance (right) with flying buttresses and a rose window.

These photos show different ways to indicate depth in your photos. Above, a steep angle emphasizes perspective, and right, the pathway adds leading lines and tree leaves help make a frame.

✉ **Addr:**	20 Dean's Yard, London SW1P 3PA	♀ **Where:**	51.499481 -0.128617
❷ What:	Abbey	**◷ When:**	Afternoon
◉ Look:	East	W **Wik:**	Westminster_Abbey

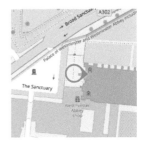

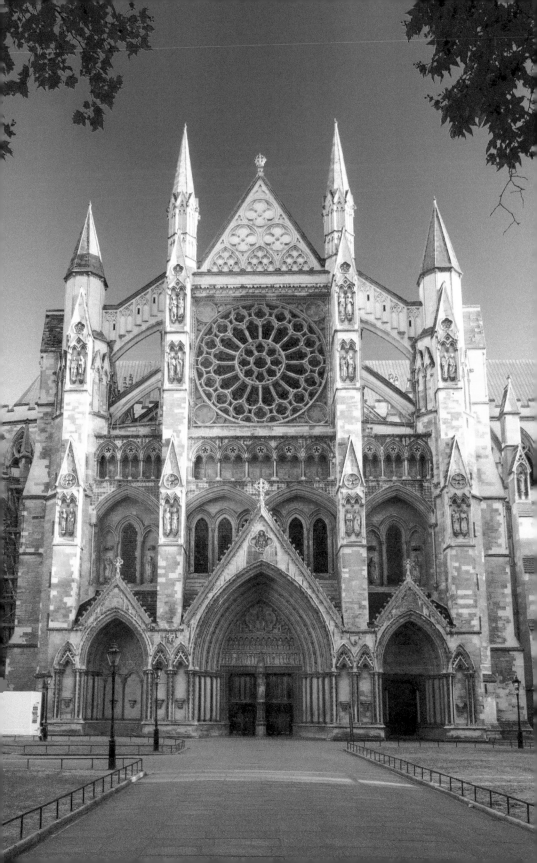

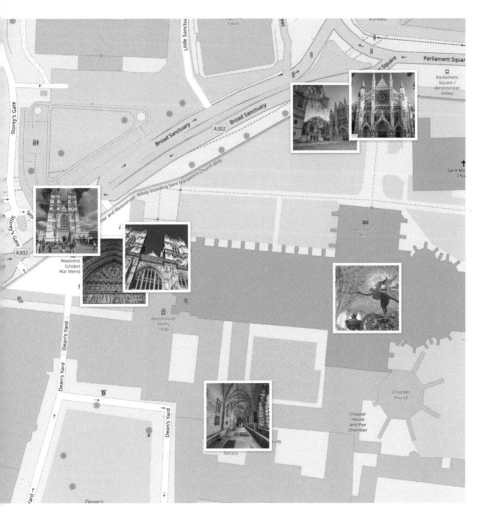

 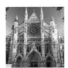

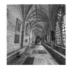 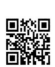 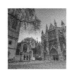

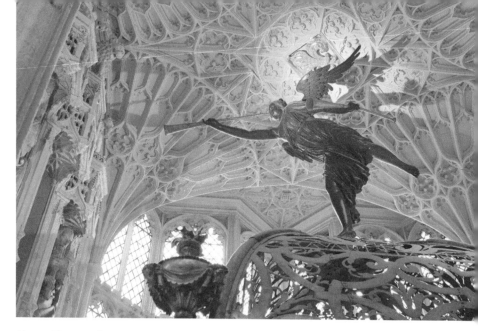

Above: The nave has an intricately ribbed vaulted ceiling.

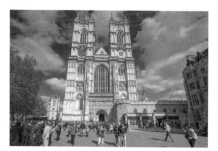
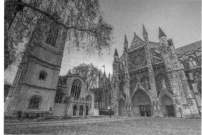

Below: The galleries surround a courtyard.

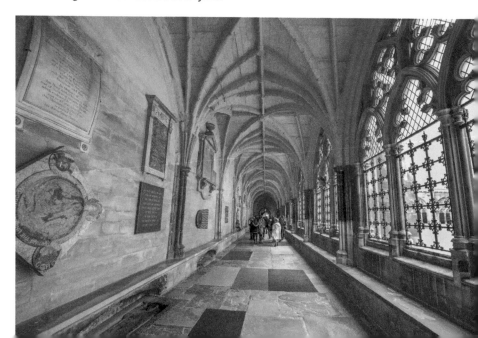

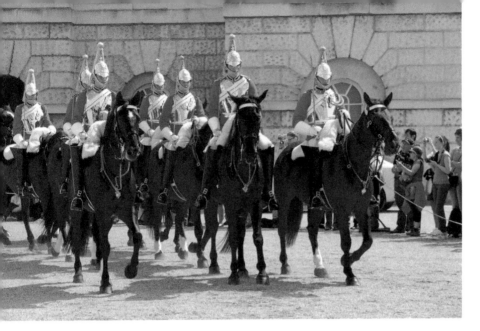

Horse Guards offers you photos of horse-mounted guards in red regalia. You can get surprisingly close to the stoic guards, but don't as horses can kick or bite.

On the west side is Horse Guards Parade, a large parade ground home to the annual Trooping of the Colour ceremony. At 4pm daily, you can photograph the guards and horses on the parade ground, after visiting the Household Cavalry Museum. Queen Victoria started the routine in 1894 when she caught guards drinking and gambling in the afternoon and punished them with a four o'clock inspection — for 100 years.

As with people, animals are best photographed at or below eye level. This is easy to accomplish with a tall horse.

✉ **Addr:**	66 Whitehall, London SW1A 2AX	⚲ **Where:**	51.5047005 -0.1278337
❓ **What:**	Building	◔ **When:**	Afternoon
👁 **Look:**	East-northeast	W **Wik:**	Horse_Guards_(building)

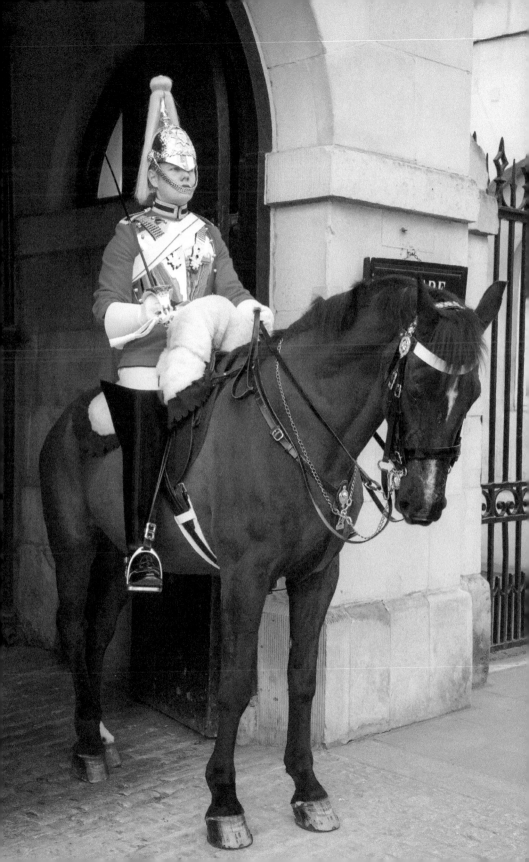

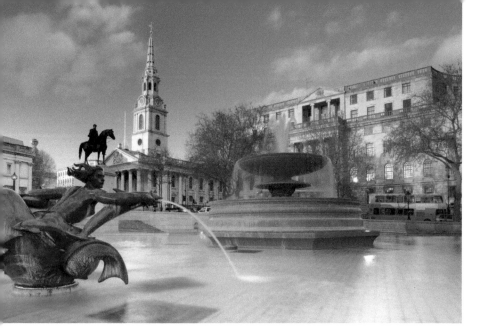

Trafalgar Square is a picturesque plaza with two fountains. You can photograph the fountains with a variety of backgrounds, including St Martin-in-the-Fields (above), Nelson's Column (right), and the National Gallery (later).

To get a smooth look to the water (above), use a slow shutter speed, such as 1/8s. You can accomplish this by using a small aperture and, on bright days, a neutral density filter.

The best place to photograph Horatio Nelson atop his column is from the equestrian statue of Charles I, which marks the official center of London. There is a plaque in the pavement to mark the point from which all distances to London are measured.

✉ **Addr:**	Trafalgar Square, London WC2N 5DN	♀ **Where:**	51.508008 -0.127853
❓ **What:**	Square	◑ **When:**	Afternoon
👁 **Look:**	Northeast	W **Wik:**	Trafalgar_Square

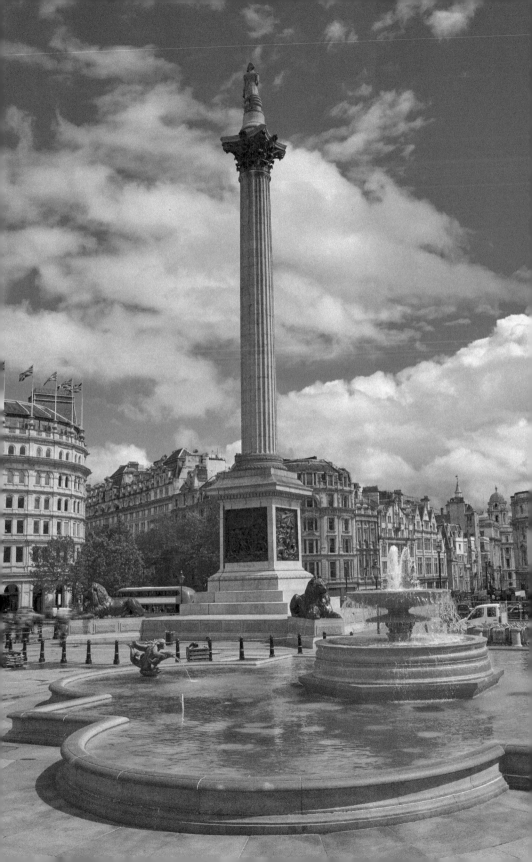

 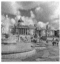

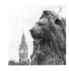

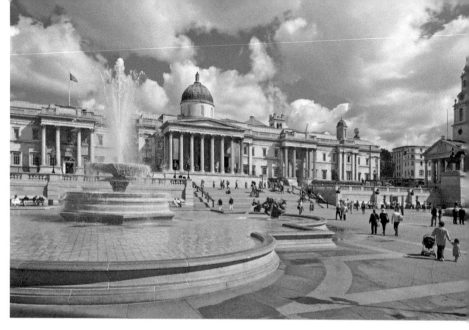

Below-left: One of Nelson's bronze lions with Big Ben.

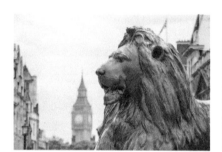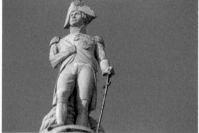

Below: Shooting into the sun provides backlighting to the water.

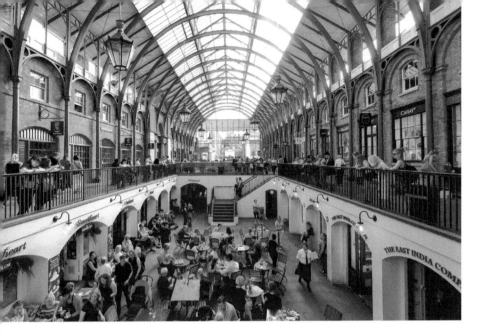

Covent Garden is a lively tourist area with street performers and cafes in and around a former fruit-and-vegetable market.

From at least 1200, the area was a walled garden owned by Westminster Abbey's monks, known by the Anglo-French term "covent" (for monastery or convent). Houses were added in 1630 around an Italian-style arcaded square, which became home to a fruit-and-vegetable market. In 1830, Charles Fowler added the neo-classical market building, with sunken courtyards and three vaulted glass roofs.Covent Garden is an excellent place to photograph people and details, to add life to your visual story.

✉ **Addr:**	The Market Bldg, London WC2E 8RF	♀ **Where:**	51.511689 -0.122998
❓ **What:**	Building	◑ **When:**	Indoors
👁 **Look:**	East-northeast	W **Wik:**	Covent_Garden

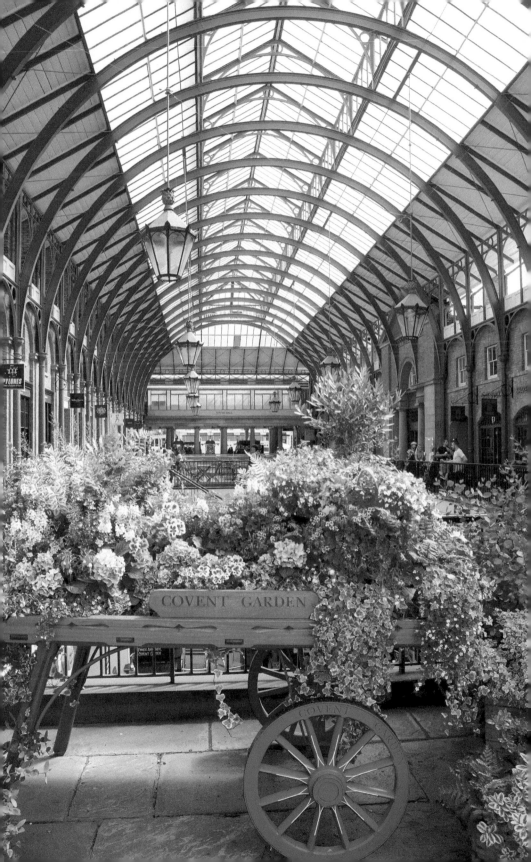

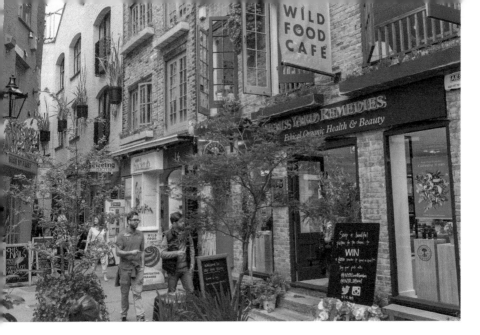

Neal's Yard is a colorful courtyard in the Covent Garden district. This is a real "secret" location which you could easily walk past without noticing, since it can't be seen from the main streets.

Neal's Yard is accessed by two nondescript alleys, off Monmouth Street and Shorts Gardens, near Neal Street. A wide-angle lens will help in the tight space.

✉ **Addr:**	Neal's Yard, London WC2H 9DP	♀ **Where:**	51.514401 -0.126351
❓ **What:**	Courtyard	🕐 **When:**	Morning
👁 **Look:**	North-northwest	W̶ **Wik:**	Neal%27s_Yard

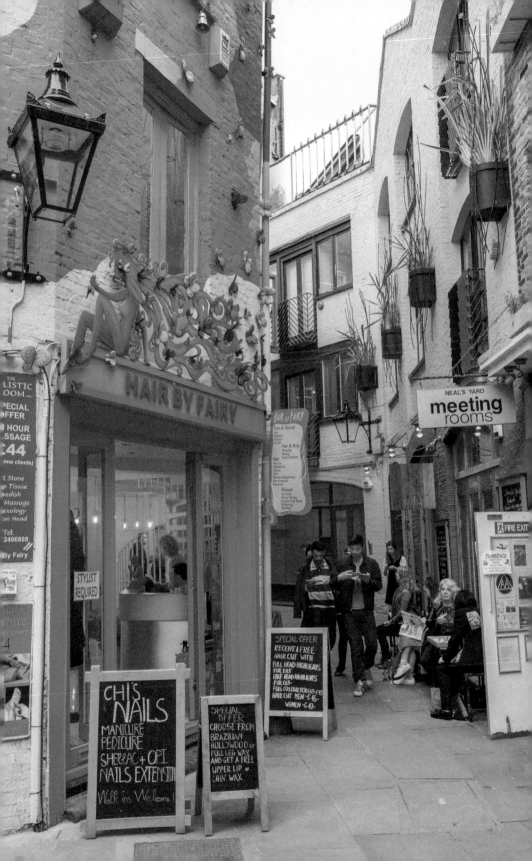

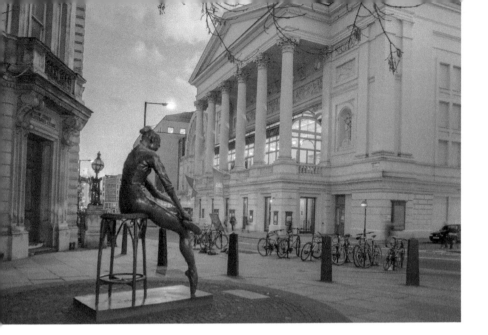

The **Royal Opera House** in Covent Garden has a neo-classical façade dating from 1858. The Royal Ballet also resides here and outside the Bow Street entrance is a suitable foreground.

Young Dancer is a ballerina statue by Enzo Plazzotta in 1988, and a gift from his estate. Behind her, on Broad Court, is a row of five red telephone boxes, so you have several photographic elements to toy with.

✉ **Addr:**	5 Broad Ct, London WC2B 5QH	♥ **Where:**	51.513629 -0.122378
❓ **What:**	Statue	☽ **When:**	Dusk
👁 **Look:**	South	↔ **Far:**	40 m (130 feet)

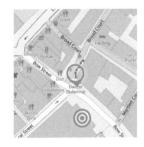

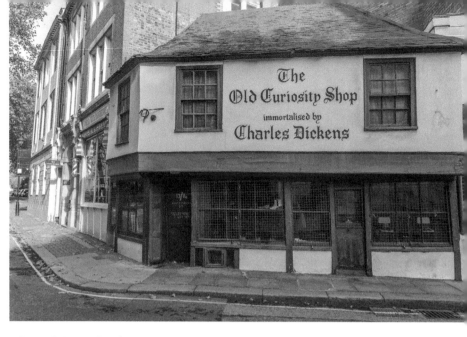

The Old Curiosity Shop is a 16th century building thought to be the inspiration for Dickens's novel. The building dates back to the sixteenth century and was built using timber from old ships. At one time it functioned as a dairy on an estate given by King Charles II to one of his many mistresses.

The name was added after release of the serialized novel, which was so popular that New York readers stormed the wharf when the ship bearing the final installment arrived in 1841.

The Old Curiosity Shop is tucked away amongst the buildings of the London School of Economics.

✉ **Addr:**	13–14 Portsmouth Street, London WC2A 2ES	♀ **Where:**	51.514848 -0.117359
❓ **What:**	Shop	☽ **When:**	Afternoon
👁 **Look:**	North	Ⱳ **Wik:**	The_Old_Curiosity_Shop

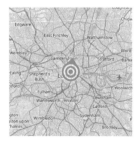
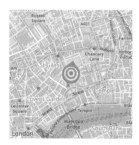
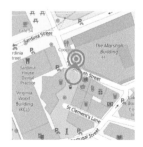

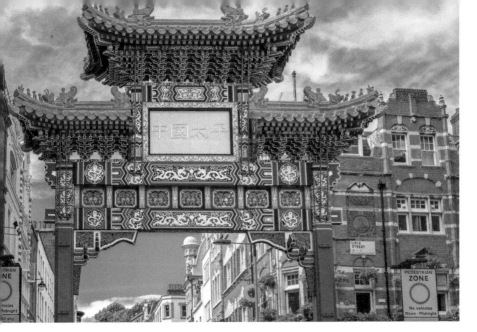

Chinatown has a colorful gate in the style of the Qing dynasty. , Built in 2016, the Chinatown gate is on Wardour Street, off Shaftesbury Avenue.

On the adjoining Gerrard Street at Macclesfield Street are a pair of Chinese lions and the decorative Lotus Garden restaurant (below).

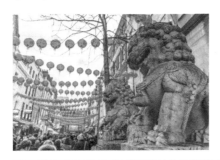

✉ **Addr:**	10 Wardour St, London W1D 6BZ	♀ **Where:**	51.510866 -0.131758
❓ **What:**	District	◑ **When:**	Morning
👁 **Look:**	Northwest	W **Wik:**	Chinatown,_London

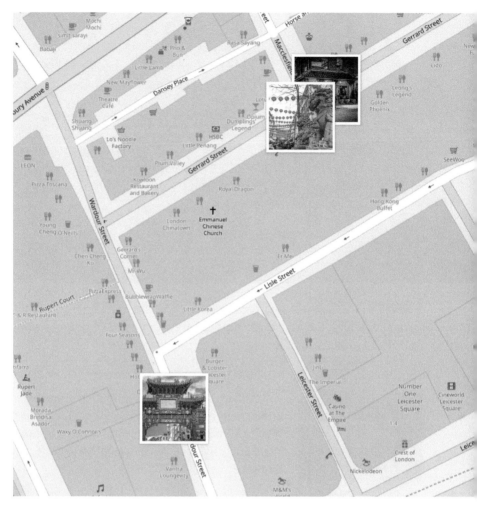

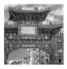

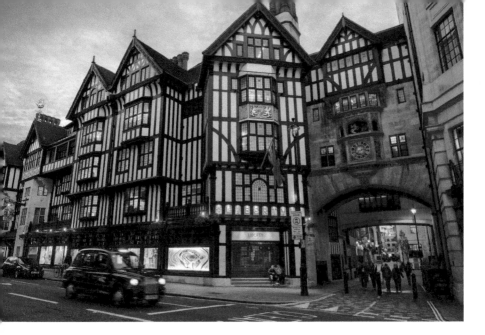

Liberty is an historic department store with a spectacular Tudor revival building. Built from the timbers of two ships, HMS *Impregnable* and HMS *Hindustan*, there are overhanging bays and a carriage arch. Inside are three light wells, and many of the rooms had fireplaces, some of which still exist.

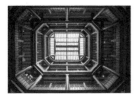

Arthur Lasenby Liberty opened a fabric and arts store in 1875 and built this black-and-white marvel in 1924. Liberty is located in the West End on Great Marlborough Street, off Regent Street.

✉ **Addr:**	Regent St, London W1B 5AH	♀ **Where:**	51.5140467 -0.140069
❓ **What:**	Department store	◑ **When:**	Dusk
👁 **Look:**	South-southwest	W **Wik:**	Liberty_(department_store)

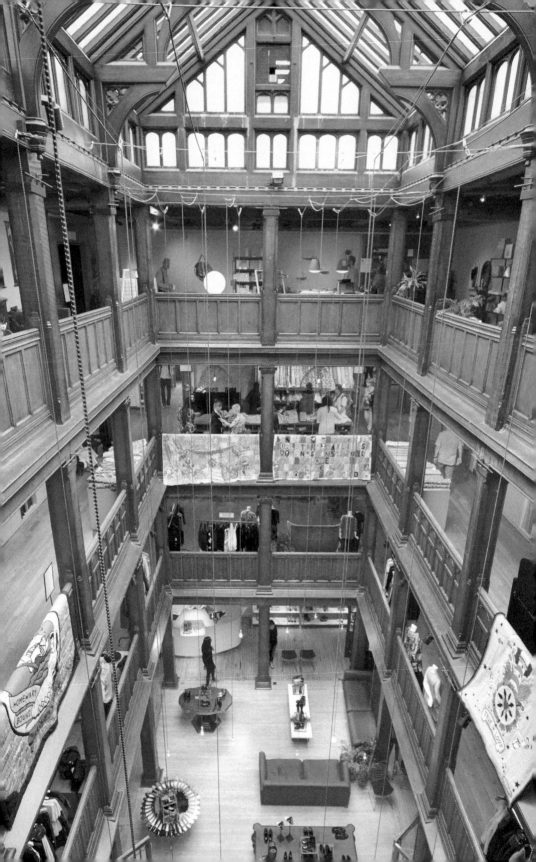

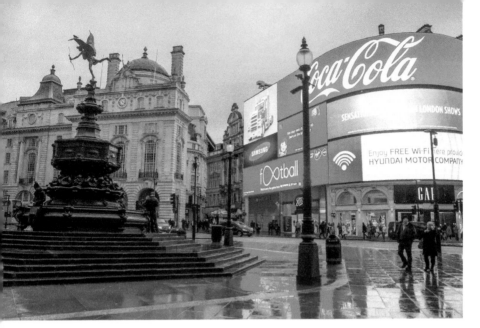

Piccadilly Circus is the Times Square of London known for its large neon signs. The busy junction was originally a traffic circle (roundabout), which is known in Latin as a circus.

The area was redesigned in the 1980s so that the circle's famous center, the Shaftesbury Memorial Fountain, was moved and is now a pedestrian area.

Atop the 1893 fountain is a statue commonly known as **Eros**, but actually of his brother, the Greek god Anteros.

✉ **Addr:**	Piccadilly Circus, London W1J 9HS	♀ **Where:**	51.509868 -0.134186	
❷ **What:**	Intersection	◑ **When:**	Morning	
👁 **Look:**	West	W **Wik:**	Piccadilly_Circus	

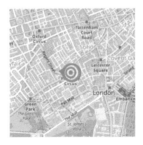
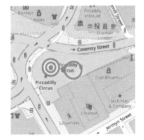

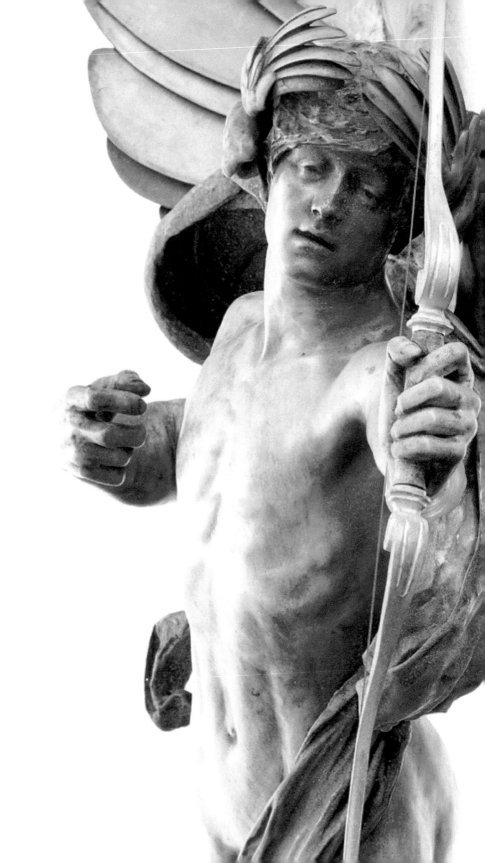

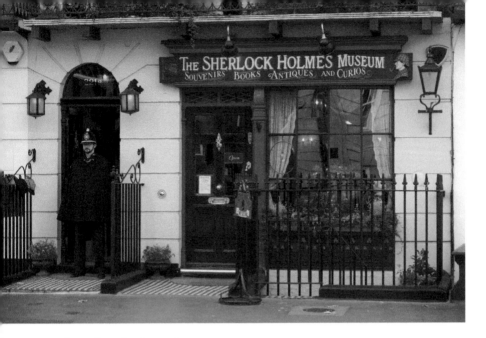

The Sherlock Holmes Museum is dedicated to the famous fictional detective. Given the famous address of 221B Baker Street, the 1815 town house was a boarding school during 1881 to 1904 when Sherlock Holmes and Doctor Watson were described in the stories as residing as tenants of Mrs Hudson.

The rooms are dressed in character so that imagining Sir Arthur Conan Doyle's hero living here is, well, elementary.

✉ **Addr:**	221B Baker St, London NW1 6XE	♥ **Where:**	51.523775 -0.158358	
❓ **What:**	Museum	☾ **When:**	Morning	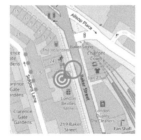
👁 **Look:**	Southwest	W **Wik:**	Sherlock_Holmes_Museum	

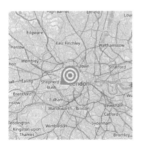
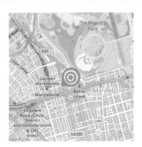

Sherlock Holmes

portrays the famous detective as a statue by John Doubleday. Unveiled in 1999, the statue was funded by the Abbey National building society, whose head office occupied the 215–229 block of Baker Street that would include number 221b.

Holmes stands outside Baker Street tube station, one of the original stations of the world's first underground railway, opened in 1863.

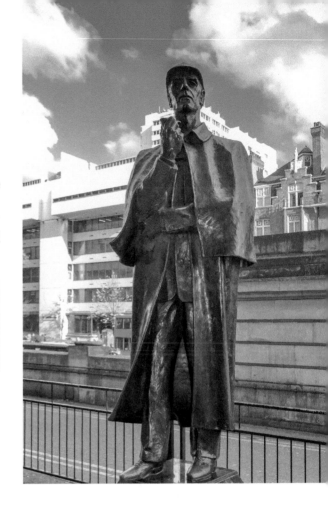

✉ **Addr:**	4 Marylebone Rd, London NW1 5LD	♀ **Where:**	51.522513 -0.156595
❓ **What:**	Statue	◑ **When:**	Afternoon
👁 **Look:**	South-southeast	↔ **Far:**	4 m (13 feet)

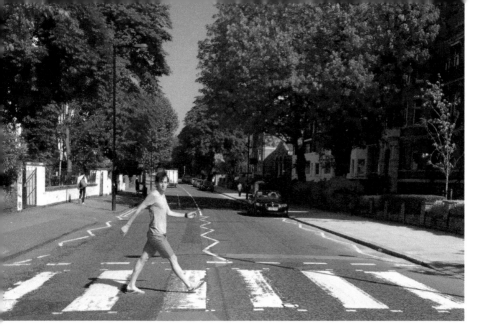

Abbey Road has the world's most famous "zebra crossing", where The Beatles were pictured on their last recorded album, "Abbey Road." You can make a fun selfie here, particularly if your group is a Fab Four, as you stride over the white-striped pedestrian crossing.

The original image was taken on 8 August 1969 outside EMI Studios at 3 Abbey Road (right). Photographer Iain Macmillan stood on a step-ladder while a policeman held up traffic behind the camera. The image has become one of the most famous and imitated in recording history.

✉ **Addr:**	3 Abbey Road, London NW8 9AY	⚲ **Where:**	51.531995 -0.177251
❓ **What:**	Zebra crossing	◐ **When:**	Morning
👁 **Look:**	Northwest	W **Wik:**	Abbey_Road

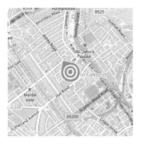
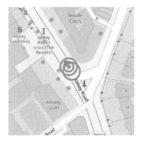

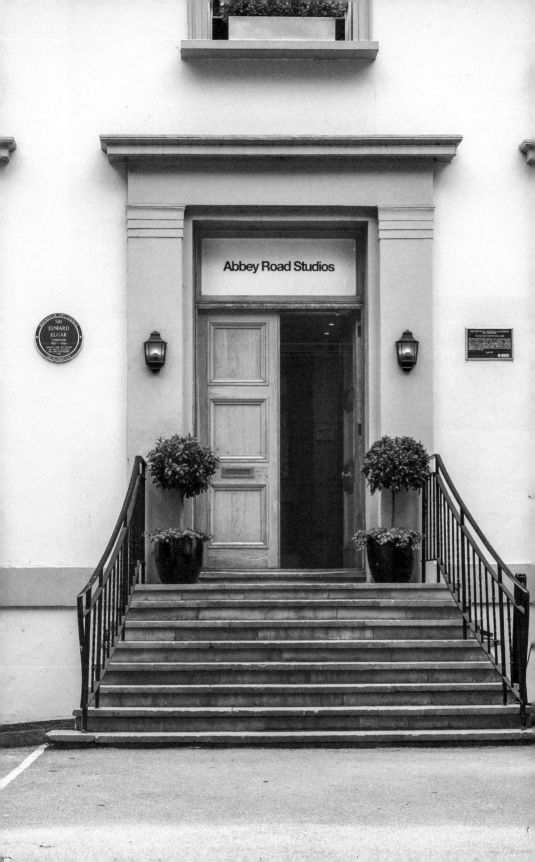

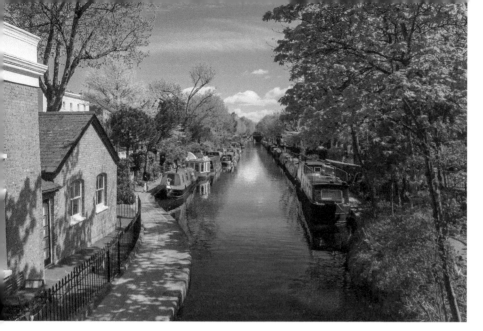

Little Venice is a scenic district around the junction of the Grand Union Canal, which opened in 1801, and Regent's Canal, opened in 1816. A bridge at Warwick Avenue affords a view up the waterway (above and below-right). The towpath by Waterside Cafe has a view of the junction and Robert Browning's Island (below-left).

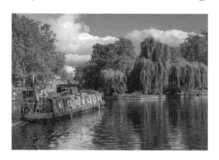

✉ **Addr:**	6 Warwick Ave, London W2 1XB	♀ **Where:**	51.521978 -0.181673
❓ What:	District	◑ **When:**	Afternoon
👁 **Look:**	Northeast	W **Wik:**	Little_Venice,_London

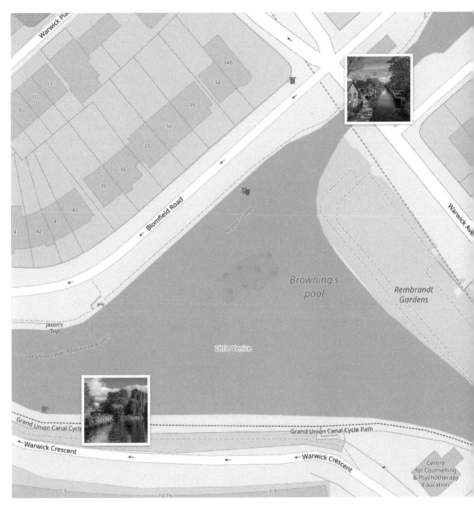

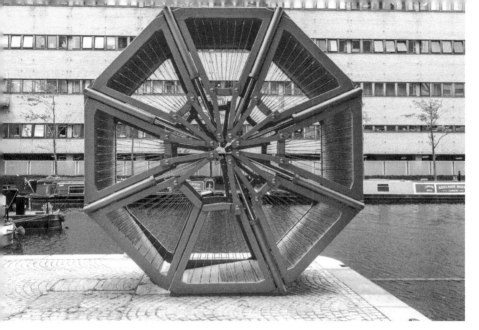

Paddington Basin is a redeveloped canal basin, southeast of Little Venice, with two unique movable footbridges. Thomas Heatherwick's **Rolling Bridge** (2004) uses eight eight triangular section and hydraulics to curl up into an octagon. There are scheduled lift times at Wednesdays and Fridays at noon, and Saturdays at 2pm.

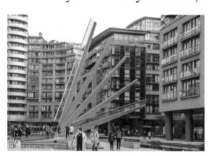

Nearby (650 feet / 200 m east), is the **Merchant Square Footbridge**, also known as Fan Bridge, which rotates up in five sections at different angles, like a Japanese fan.

✉ **Addr:**	S Wharf Rd, London W2 1NW	♀ **Where:**	51.518449 -0.174623	
❓ **What:**	District	☾ **When:**	Afternoon	
👁 **Look:**	South-southeast	W **Wik:**	Paddington_Basin	

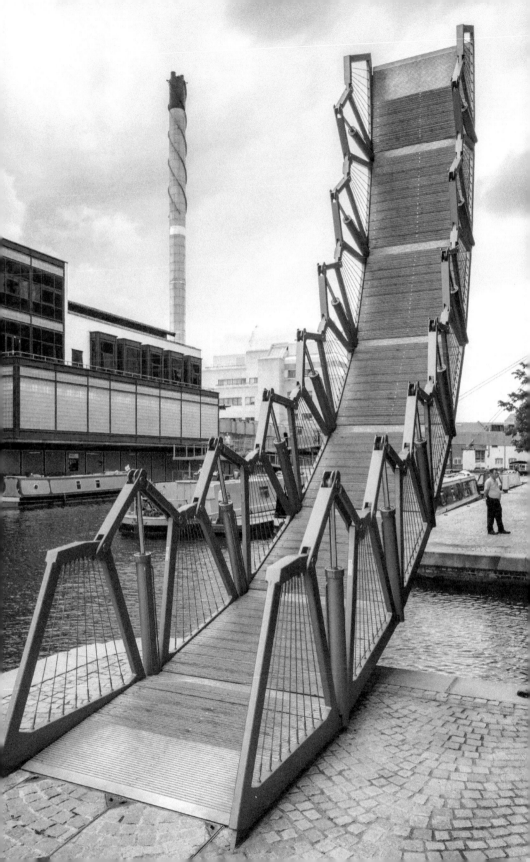

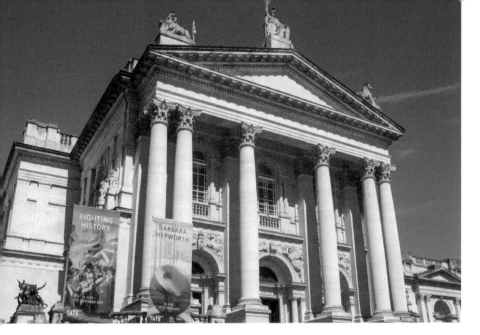

Tate Britain is the oldest gallery in the Tate network, opening in 1897. It houses a substantial collection of the works of J. M. W. Turner.

Founded by Sir Henry Tate, an English sugar refiner who owned the patent for making sugar cubes, the museum is located south of the Houses of Parliament. The building has a classical portico (above) and, behind it, a rotunda with a skylit dome (right top). In the north wing by the Millbank entrance is a spiral staircase (right bottom).

Outside, is Millbank Millennium Pier where a high-speed boat can whisk you down the Thames (north and east) to the Tate Modern, 2.1 miles (3.4 km) away.

✉ **Addr:**	Millbank, London SW1P 4RG	♀ **Where:**	51.490529 -0.126767
❓ **What:**	Art museum	◐ **When:**	Morning
👁 **Look:**	North-northwest	W **Wik:**	Tate_Britain

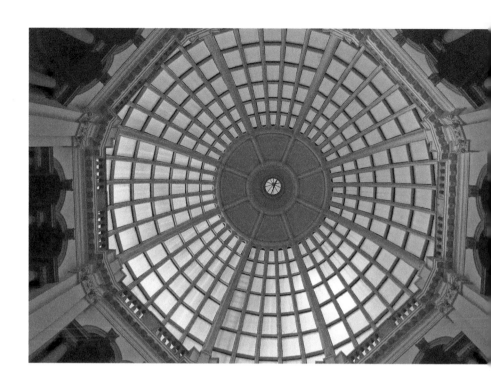

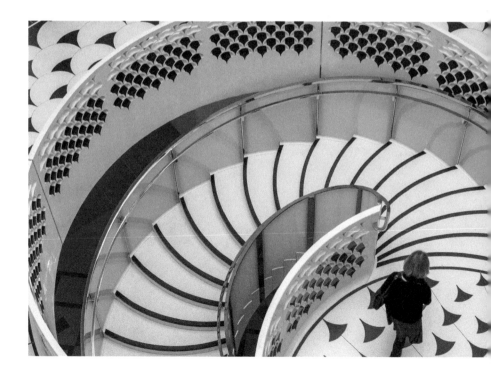

City of Westminster > Millbank > Tate Britain

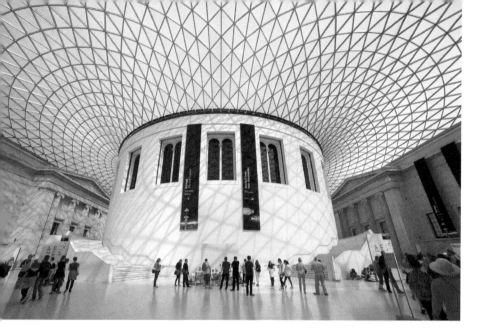

The **British Museum** is one of the world's largest and most famous museums. Established in 1753, the museum has an impressive entrance (below) along Great Russel Street. Inside, the Great Court (above) is the largest covered square in Europe, with a tessellated glass roof around the original Reading Room (below).

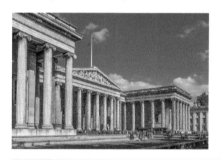

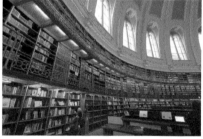

✉ **Addr:**	Great Russell St, London WC1B 3DG	♥ **Where:**	51.5190537 -0.1266025	
❓ **What:**	Museum	☽ **When:**	Morning	
👁 **Look:**	North-northwest	Ⓦ **Wik:**	British_Museum	

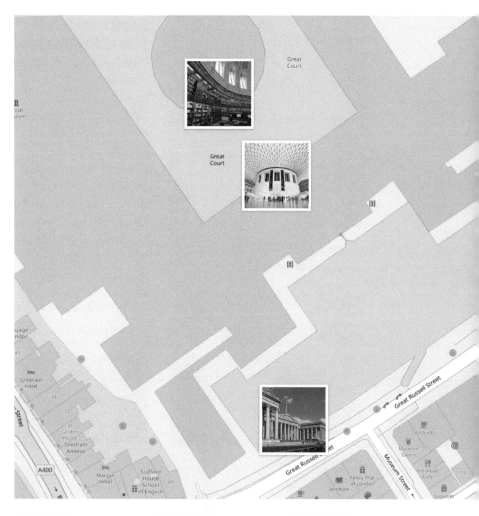

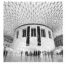 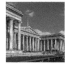 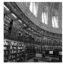

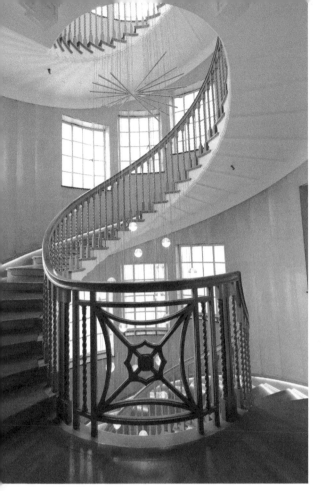

Cecil Brewer Spiral Staircase is

billed as London's most photographed staircase. Located inside Heal's Furniture Store on Tottenham Court Road, the graceful 1916 design is by Ambrose Heal's cousin, the architect by Cecil Brewer. A Bocci chandelier added in 2013 provides a sparkling center to shots from above (right) or below (pictured above).

✉ **Addr:**	196 Tottenham Court Rd, London W1T 7LQ	♀ **Where:**	51.521316 -0.134172
❓ **What:**	Staircase	⏲ **When:**	Indoors
👁 **Look:**	Up	Ⓦ **Wik:**	Heal%27s

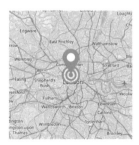

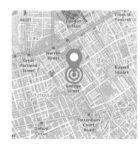

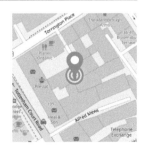

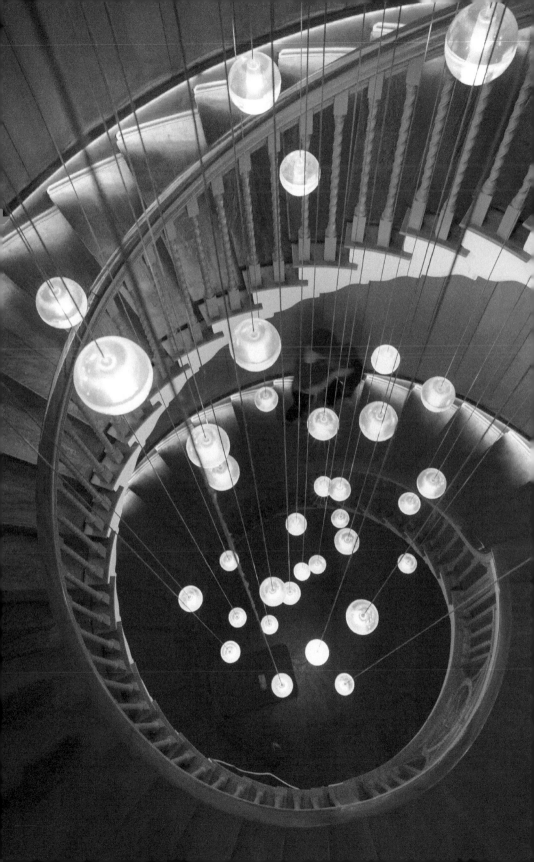

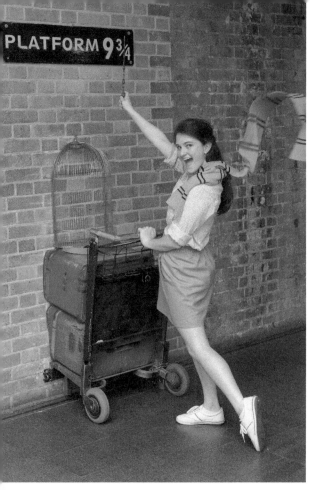

London King's Cross is a major London railway terminus, particularly for journeys to Hogwarts. Opened in 1852, this is where the fictional wizard and his friends dashed through a brick wall to catch the Hogwarts Express.

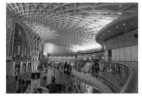

You can take a magical selfie at a picture area in the station concourse. Oddly enough, this is located next to the Harry Potter shop.

✉ **Addr:**	Euston Rd, London N1 9AL	♀ **Where:**	51.532143 -0.123969	
❷ **What:**	Railway station	◐ **When:**	Indoors	
👁 **Look:**	Southeast	W **Wik:**	London_King%27s_Cross_railway_station	

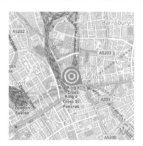

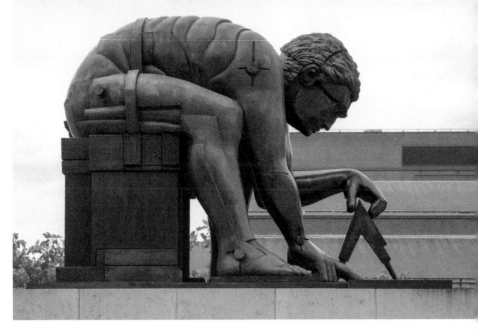

Newton, after William Blake,

is a large bronze heroic representation of Sir Isaac Newton, one of the most influential scientists of all time. Designed by Eduardo Paolozzi in 1995, the sculpture is based on William Blake's study that pictured the flexible Newton drawing with a compass.

The sculpture is located in the piazza of the British Library, along Euston Road. While you're there, check out the tower of King's Library, behind smoked glass.

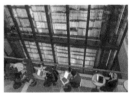

✉ **Addr:**	96 Euston Rd, London NW1 2DB	♀ **Where:**	51.5289958 -0.1274612
❓ **What:**	Statue	◑ **When:**	Morning
👁 **Look:**	West-northwest	W **Wik:**	British_Library

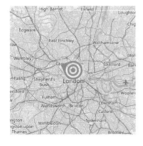
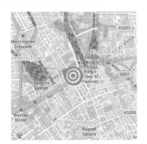

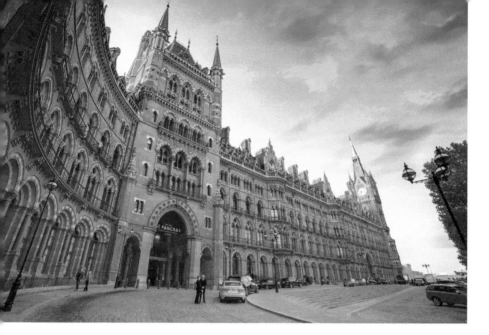

St Pancras International is a glorious Victorian edifice. The frontispiece (above) is a hotel opened in 1873 with a grand staircase (later). The arched entrance (below right) leads to a 30-foot (9 m) high sculpture called *The Meeting Place* (2007, Paul Day) and *Sir John Betjeman* (2007, Martin Jenning).

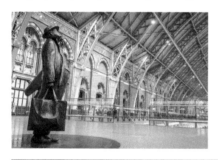
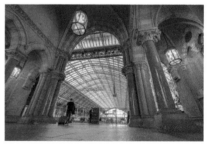

✉ **Addr:**	Euston Rd, London N1C 4QP	♀ **Where:**	51.529315 -0.125871	
❷ **What:**	Railway station	☽ **When:**	Morning	
👁 **Look:**	North	W **Wik:**	St_Pancras_railway_station	

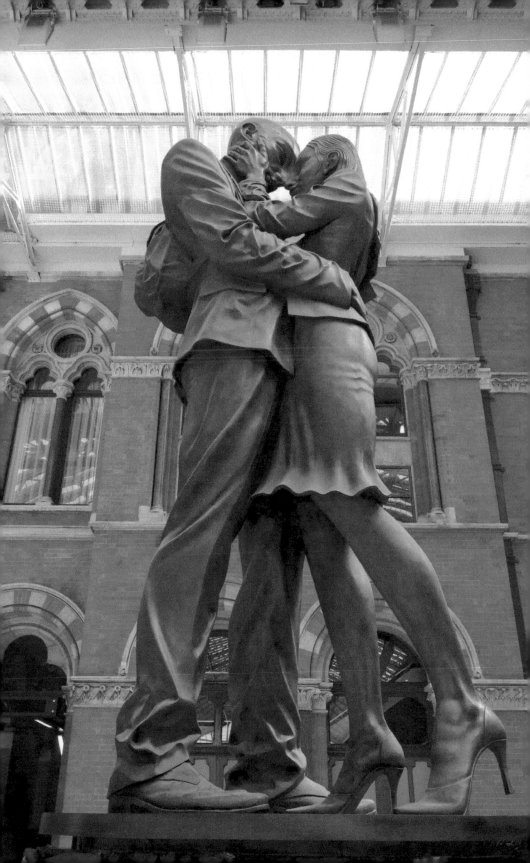

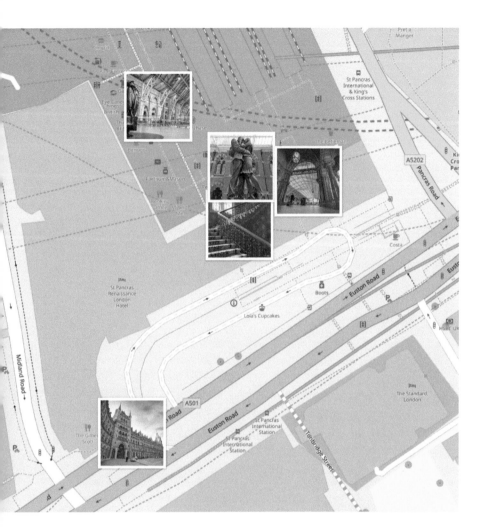

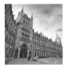

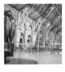

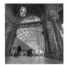

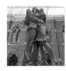

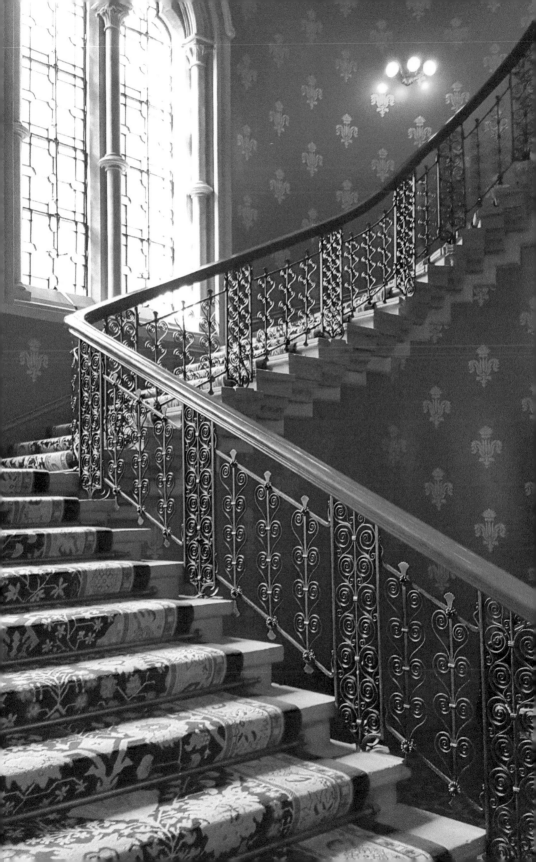

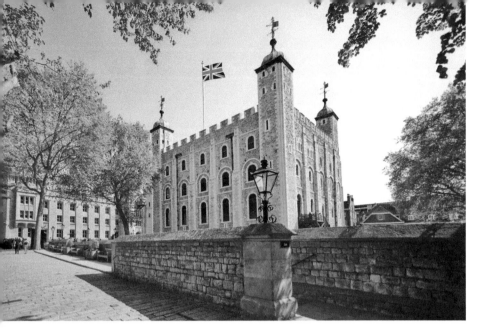

The **Tower of London** is where Beefeaters guard the Crown Jewels. The White Tower (above) gives the castle its name and was built by William the Conqueror in 1078 following the Norman Conquest of England. The complex includes two concentric rings of defensive walls and a moat.

North of the White Tower is Jewel House which houses the Crown Jewels. This is the best place for close-up photographs of the Queen's Guard (right), two of whom stand sentry on the west side of the entrance to Jewel House.

Beefeaters (Yeoman Warders) are retired soldiers and guardians of the Tower of London. Other guards include the famous ravens, at least six of which are kept are kept at the Tower at all times, believing that if they are absent, the kingdom will fall.

✉ **Addr:**	St Katharine's and Wapping, London EC3N 4AB	♀ **Where:**	51.507724 -0.076829
❓ **What:**	Tower	☾ **When:**	Afternoon
👁 **Look:**	East-northeast	W **Wik:**	Tower_of_London

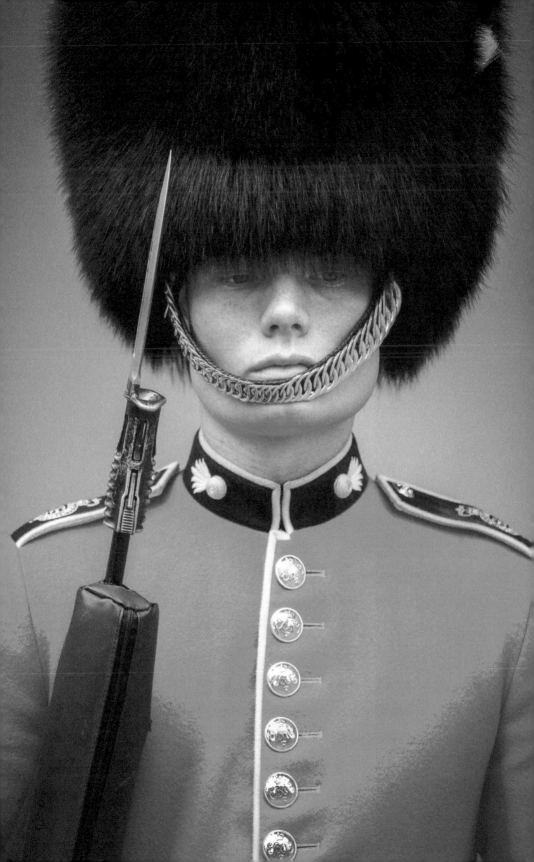

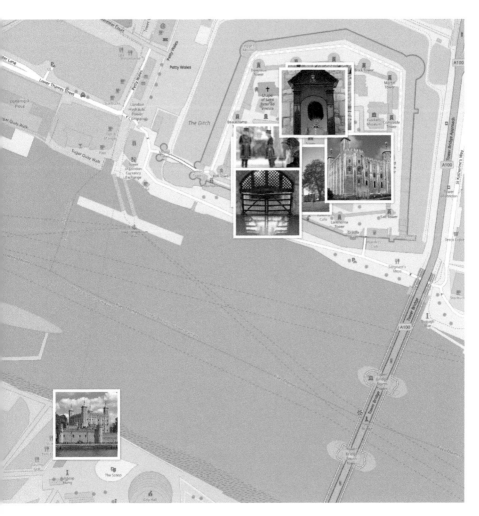

 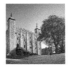

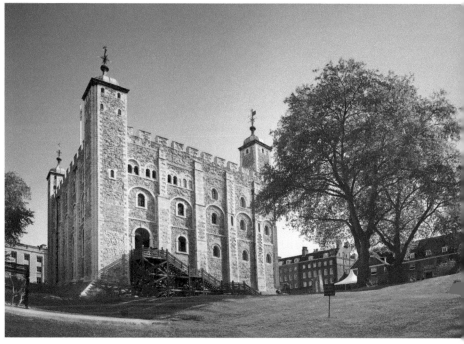

Above: The White Tower and Traitors' Gate (the lower arch) as viewed across the Thames by London City Hall.
Below: Beefeaters and a raven.

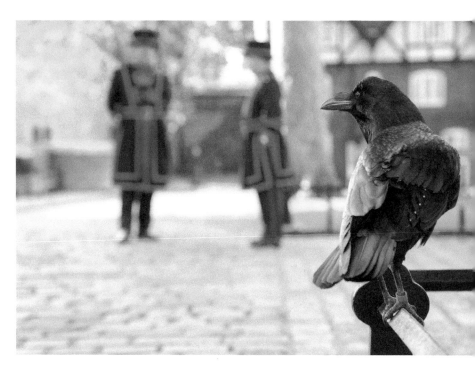

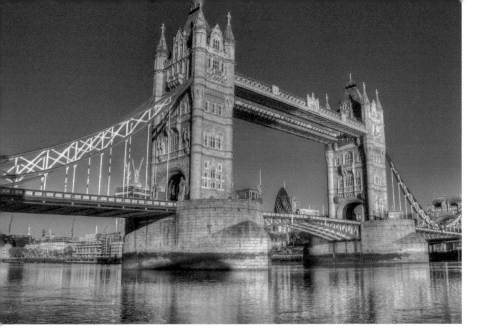

Tower Bridge is an iconic symbol of London. Named for the nearby Tower of London, it is sometimes incorrectly called London Bridge.

Built between 1886 and 1894, Tower Bridge is recognizable for its two Gothic towers on piers. The two halves of the center roadway fold upwards to allow ships to pass. Scheduled lift times are posted in advance at www.towerbridge.org.uk/lift-times/.

You can photograph Tower Bridge from a multitude of places. The classic view above is from the south, along a pedestrian path accessed by an arched alley called Maggie Black's Cause. Arrive in the late afternoon to get golden light on the stonework.

✉ **Addr:**	Tower Bridge Rd, London SE1 2UP	♀ **Where:**	51.504068 -0.07478	
❷ **What:**	Bridge	☾ **When:**	Morning	
👁 **Look:**	North-northwest	W **Wik:**	Tower_Bridge	

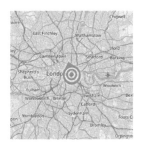
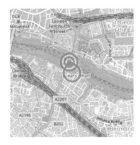

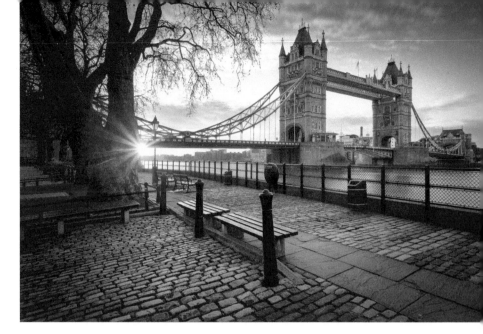

Above: From Tower Wharf by the Tower of London, at sunrise.

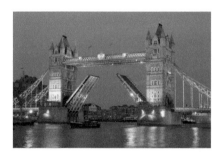 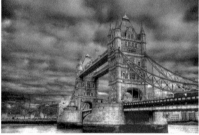

Below: With "Girl with a Dolphin" at St Katharine Docks.

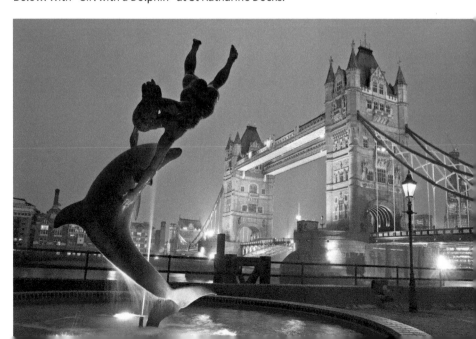

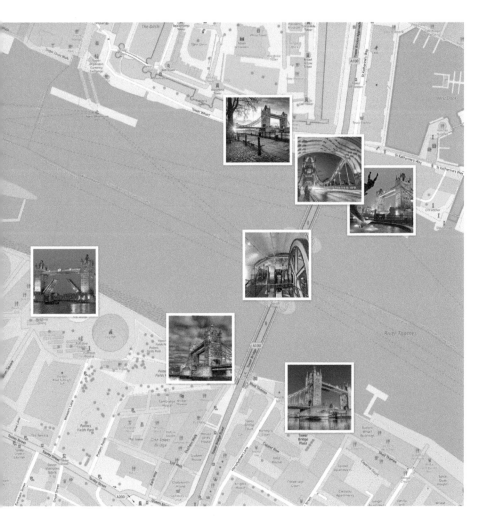

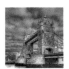
 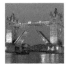
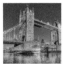 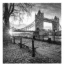 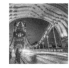
 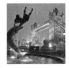

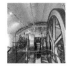

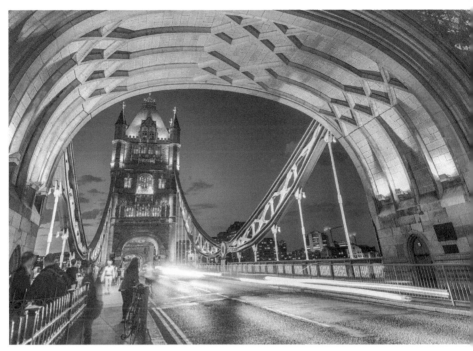

You can walk across the bridge for free (above) and, for a fee, enter Tower Bridge Exhibition to see the original steam engines (below). You can also cross the high-level walkways that now have glass floors.

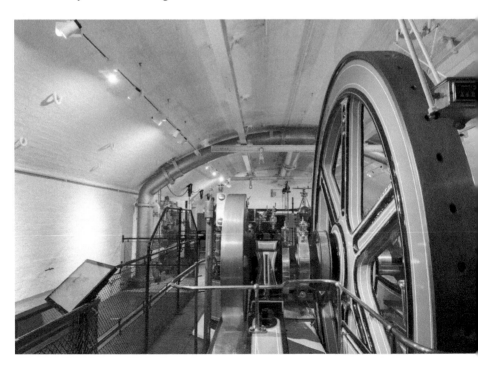

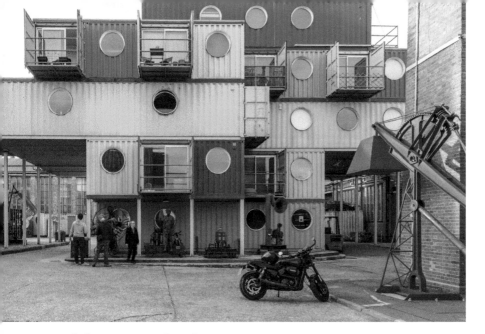

Trinity Buoy Wharf is an arts and culture area on the River Thames, about 4.5 miles (7.3 km) east of the City of London.

In the center is **Container City 2** (above), a 2002 studio and office complex made from 22 recycled sea shipping containers in a colorful ziggurat. Docked at the wharf is the bright red **Light Vessel 93** (right), built in Devon in 1938 and used as a photographic studio and location.

Overlooking the Thames is London's only lighthouse. **Trinity Buoy Wharf Light**, also known as Bow Creek Lighthouse, was built in 1864–66 by James Douglass and was used to test lighting systems for other lighthouses. Michael Faraday carried out experiments here.

✉ **Addr:**	64 Orchard Pl, London E14 0JW	♀ **Where:**	51.508026 0.008560
❓ **What:**	Wharf	◑ **When:**	Morning
👁 **Look:**	West-northwest	W **Wik:**	Trinity_Buoy_Wharf

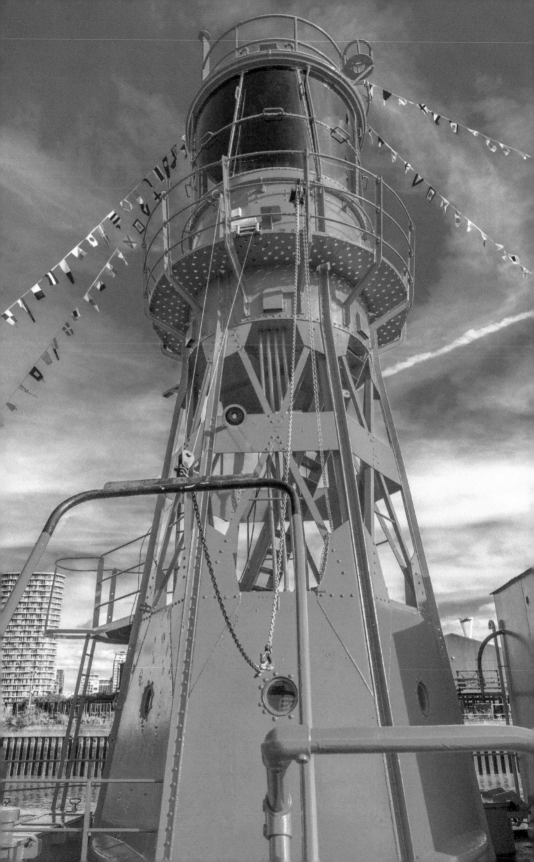

Colour
Holographic

Container
City

Trinity
Buoy Wharf

Boiler
House

Light
Ship
95

Bow Creek
Cafe

Chain
Store

Clipper
House

Fatboy's
Diner

Trinity
Buoy Lighthouse

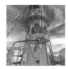

Above: Taxis are no longer invited to park by Lightship LV93.
Below: London's only lighthouse.

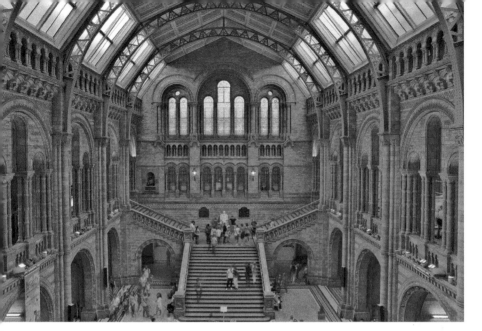

The Natural History Museum has an ornate Romanesque terracotta facade on Cromwell Road (below and later). Inside, the main Hintze Hall (above) has skylights, an imperial staircase, and large niches for exhibits (right).

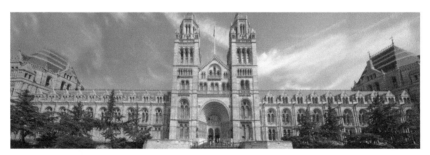

✉ **Addr:**	Cromwell Rd, London SW7 5BD	♀ **Where:**	51.496031 -0.176372
❓ What:	Museum	**◑ When:**	Morning
👁 Look:	North	**W Wik:**	Natural_History_Museum,_London

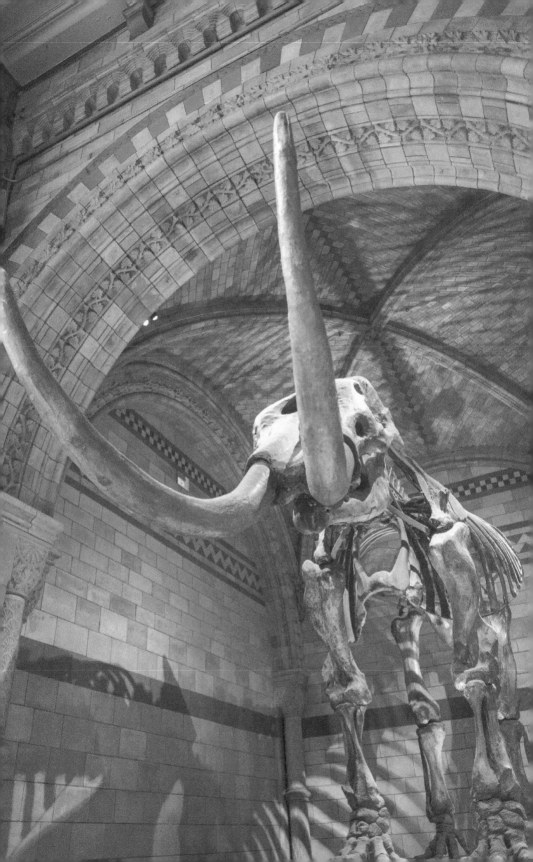

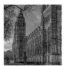

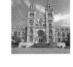

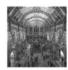

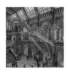

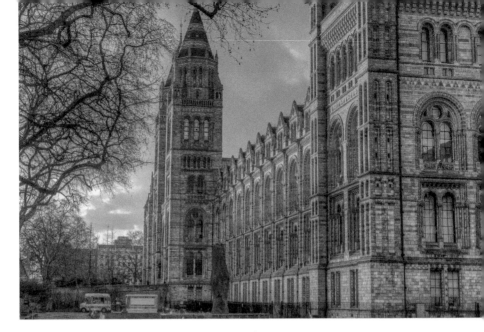

Above: Late afternoon light, viewed from east of the entrance.

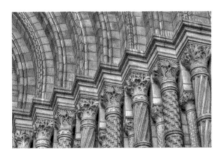 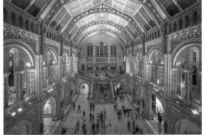

Below: A blue whale skeleton hangs in Hintze Hall.

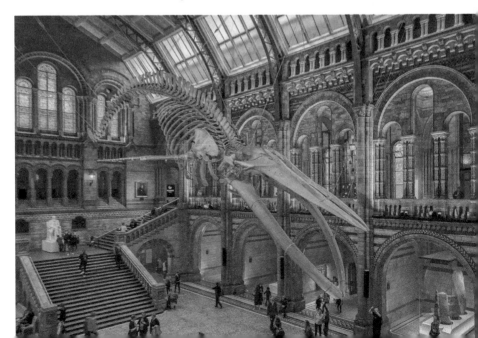

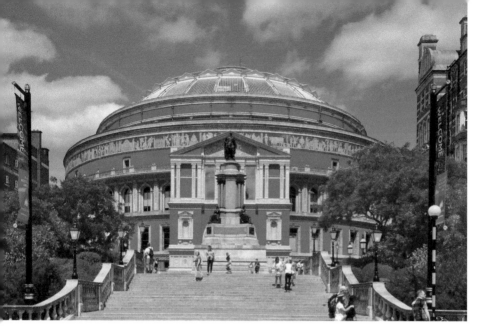

The **Royal Albert Hall** is best known for holding the annual summer Proms concerts since 1941. You can photograph the 1871 main entrance (above) on the south side from Prince Consort Road, and the north entrance (below right) from Kensington Gardens. Paid tours include the auditorium (below left).

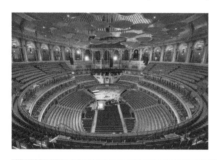 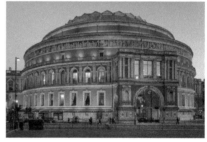

✉ **Addr:**	Kensington Gore, London SW7 2AP	♀ **Where:**	51.499919 -0.177192
❓ **What:**	Hall	☽ **When:**	Morning
👁 **Look:**	North	W **Wik:**	Royal_Albert_Hall

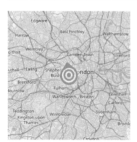 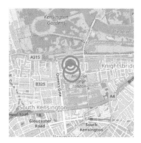 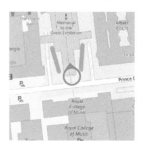

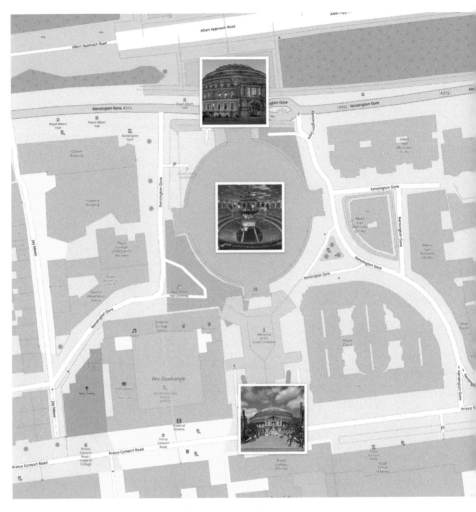

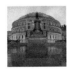 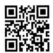 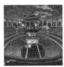 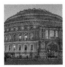

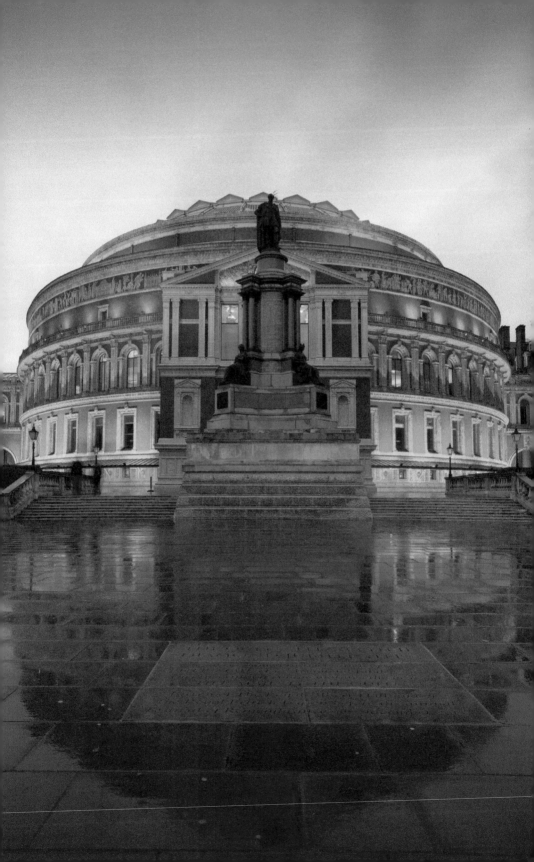

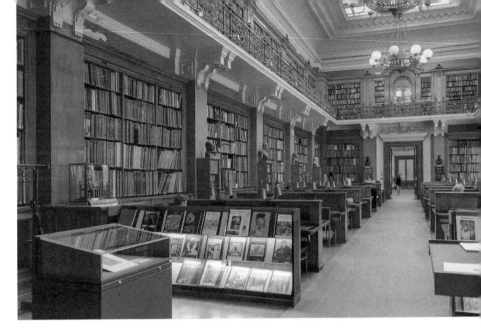

The **National Art Library** is a major reference library, open free to the public (Tue–Sat). The library is on the first floor of the Victoria and Albert Museum, the world's largest museum of applied and decorative arts and design.

✉ **Addr:**	2 Cromwell Rd, London SW7 4EF	♀ **Where:**	51.4968 -0.17262
❓ **What:**	Library	◑ **When:**	Indoors
👁 **Look:**	East	W **Wik:**	National_Art_Library

North Bank > Royal Borough of Kensington and Chelsea > South Kensington > Albertopolis > Victoria and Albert Museum > National Art Library

105

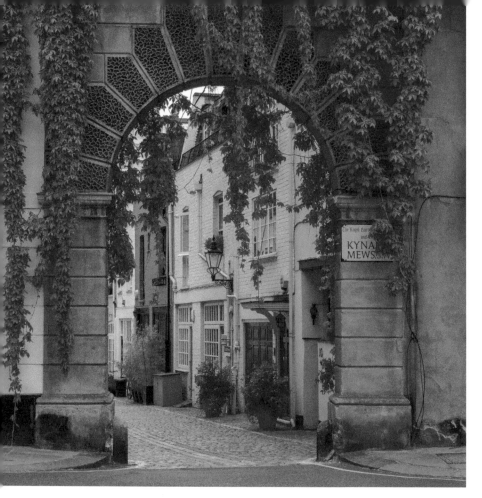

Kynance Mews is a popular Instagram spot. Grand arches lead to a cobblestone road lined with quaint servants' quarters built over stables and carriage houses.

✉ **Addr:**	Kensington, London SW7 4QS	📍 **Where:**	51.4974864 -0.1837557
❷ **What:**	Street	☾ **When:**	Morning
👁 **Look:**	West-southwest	Ⓦ **Wik:**	Kynance_Mews

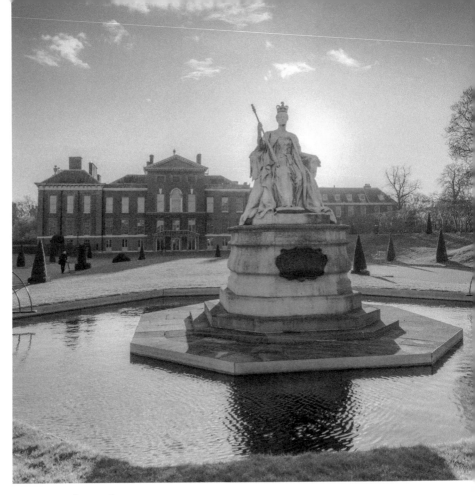

Queen Victoria is an 1893 statue near Kensington Palace. This view is from the west side of Kensington Gardens and puts the sun behindHer Majesty as a backlight.

✉ **Addr:**	Kensington Gardens, London W8 4PX	♀ **Where:**	51.505405 -0.185834
❓ **What:**	Statue	☾ **When:**	Morning
👁 **Look:**	West-southwest	Ⓦ **Wik:**	Queen_Victoria

North Bank > Royal Borough of Kensington and Chelsea > Kensington > Kensington Gardens > Kensington Palace > Queen Victoria

107

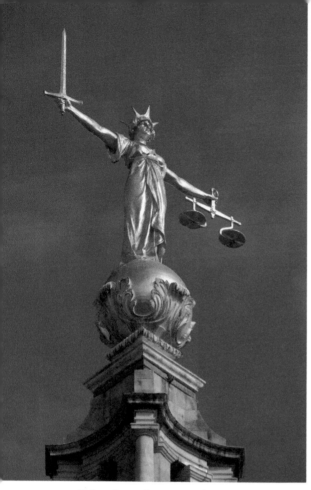

Lady Justice finds the iconic legal figure atop the Old Bailey courthouse. Designed by British sculptor F. W. Pomeroy, she holds aloft a pair of scales and a sword, symbolizing her fairness and authority.

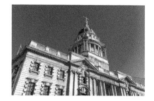

Below her, the Central Criminal Court deals with major criminal cases from within Greater London and in exceptional cases from England and Wales.

This view is from Bishop's Court.

✉ **Addr:**	The Old Bailey, London EC4M 7EH	♀ **Where:**	51.516077 -0.102267
❓ **What:**	Sculpture	⏻ **When:**	Afternoon
👁 **Look:**	Southeast	W **Wik:**	Old_Bailey

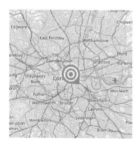
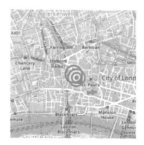
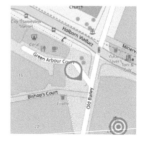

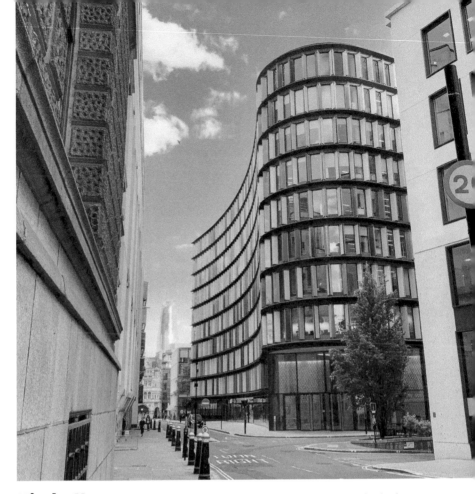

Mizuho House is a wave-like building with multi-coloured window louvres that look like books in a giant library. Located near the Old Bailey and officially called 2 New Ludgate, the 2015 building is leased to Mizuho Bank.

✉ **Addr:**	30 Old Bailey, London EC4M 7AU	📍 **Where:**	51.5157555 -0.1020976
❓ **What:**	Building	☾ **When:**	Morning
👁 **Look:**	South-southwest	W **Wik:**	Mizuho_Bank

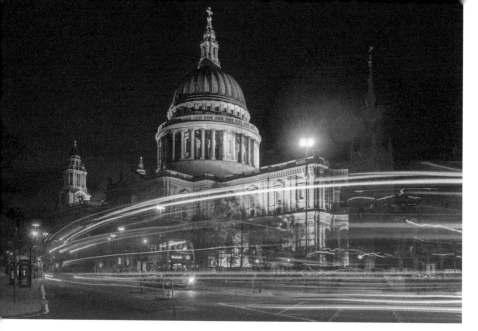

St Paul's Cathedral is the masterpiece of Britain's most famous architect, Sir Christopher Wren. Built in 1675 after the Great Fire of London, the dome was the tallest building in London until 1967.

Since 604, there has been a church at this site, the highest point of the City of London. Today, you can photograph from all around the cathedral, with the best views from the southeast corner, along St. Paul's Churchyard (above) and Festival Gardens (right). After capturing shots of the grand central dome, you can climb steps to galleries above the dome. The Golden Gallery, just below the cross on the top, offers panoramic views of the London skyline.

✉ **Addr:**	St. Paul's Churchyard, London EC4M 8AD	♀ **Where:**	51.513026 -0.09737
❓ **What:**	Cathedral	◑ **When:**	Dusk
👁 **Look:**	Northwest	W **Wik:**	St_Paul%27s_Cathedral

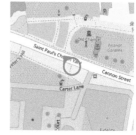

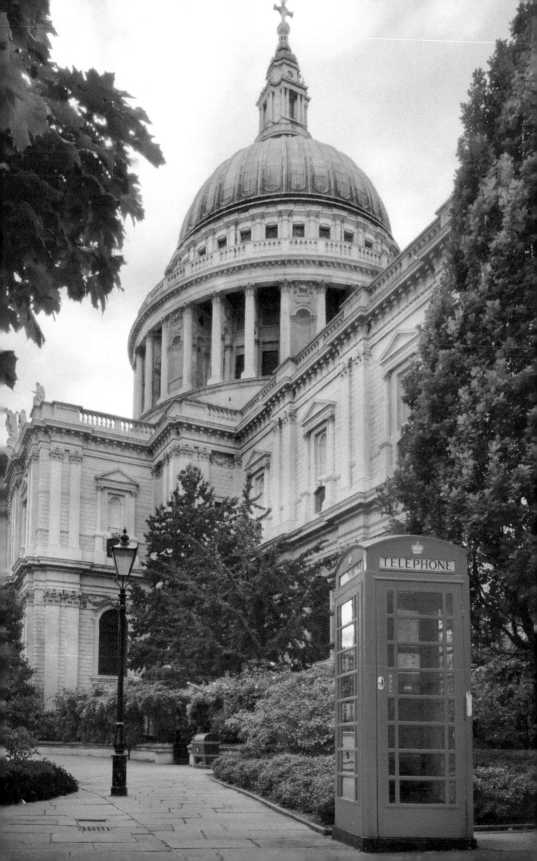

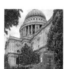

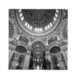

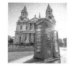

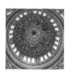
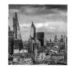

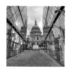

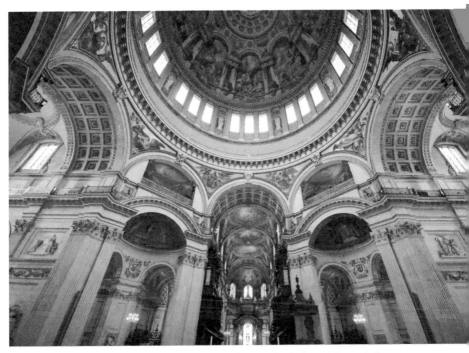

The magnificent Baroque dome in the center of the cathedral. A wide-angle lens helps here.

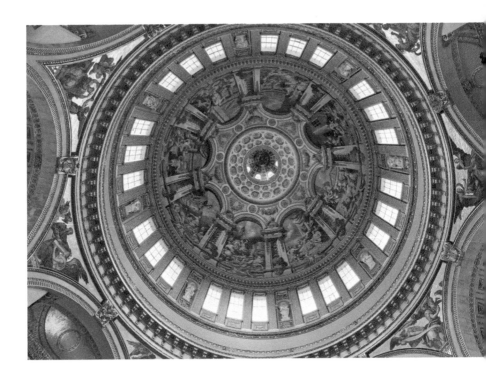

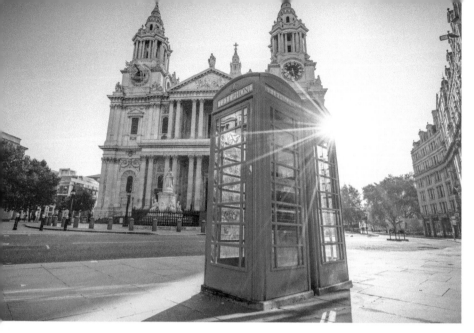

Below: The London skyline from the Golden Gallery, 528 steps high.

Below: One New Change. Right: Stairs to the galleries.

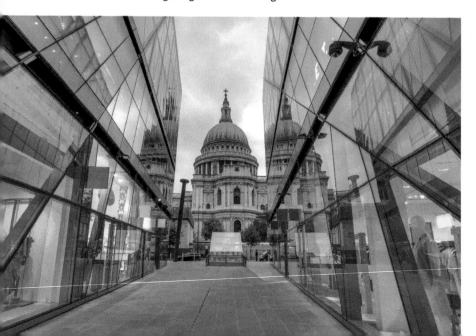

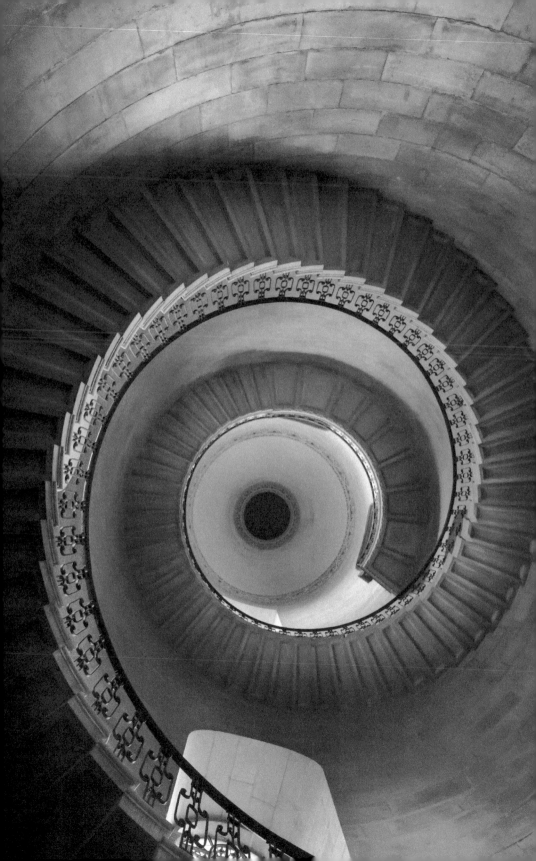

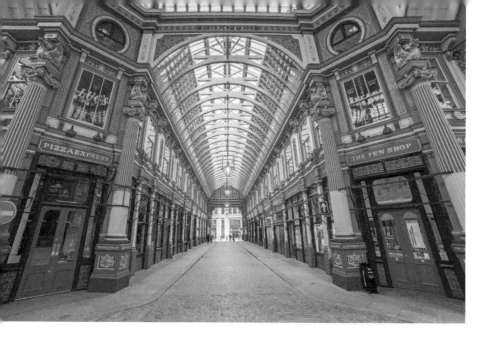

Leadenhall Market is a spectacular covered market, used as Diagon Alley in the Harry Potter films.

Dating from the 14th century, this is one of the oldest markets in London and stands on what was the center of Roman London. Sir Horace Jones designed the ornate Victorian structure in 1881, which has cobbled floors and a color scheme of green, maroon and cream.

These views are all taken with a wide-angle lens from the north entrance at Whittington Avenue.

✉ **Addr:**	Gracechurch St, London EC3V 1LR	♀ **Where:**	51.512752 -0.083473
❷ **What:**	Market	◑ **When:**	Indoors
👁 **Look:**	South-southwest	W **Wik:**	Leadenhall_Market

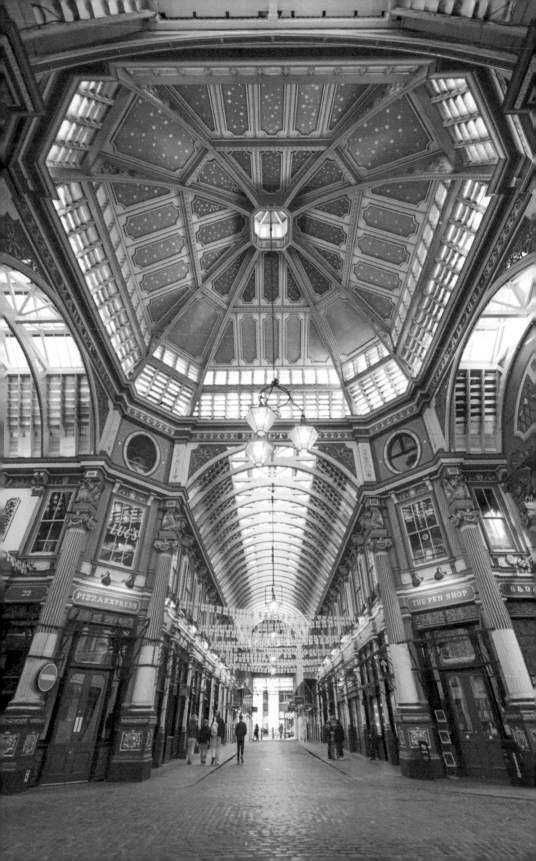

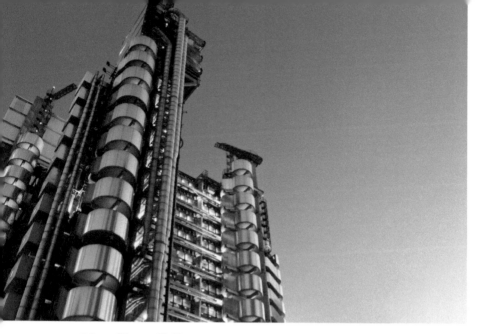

The **Lloyd's Building** is known as the "Inside-Out Building" since services such as ducts and lifts are on the exterior to maximize the interior space. Built 1978–1986 on Lime Street, the building is best photographed from Leadenhall Street, by the northeast stairwell tower, toward 30 St Mary Axe.

Unfortunately there are no public tours of the interior.

✉ **Addr:**	One Lime Street, London EC3M 7HA	♥ **Where:**	51.51363 -0.081515
❓ **What:**	Building	◑ **When:**	Morning
👁 **Look:**	Southwest	W **Wik:**	Lloyd%27s_building

30 St Mary Axe is known as "The Gherkin" for its unusual bulging shape. One of the city's most widely recognized examples of modern architecture, the 2001 skyscraper was designed by Norman Foster and Arup Group.

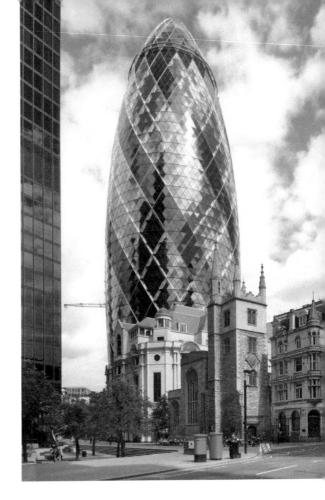

This view is from Leadenhall Street, by the Lloyd's building. In the foreground is St Andrew Undershaft, a rare example of a City church that survived both the Great Fire of London and the Blitz.

✉ **Addr:**	30 St Mary Axe, London EC3A 8EP	♥ **Where:**	51.513446 -0.081877
❷ **What:**	Building	◔ **When:**	Afternoon
◉ **Look:**	Northeast	W **Wik:**	30_St_Mary_Axe

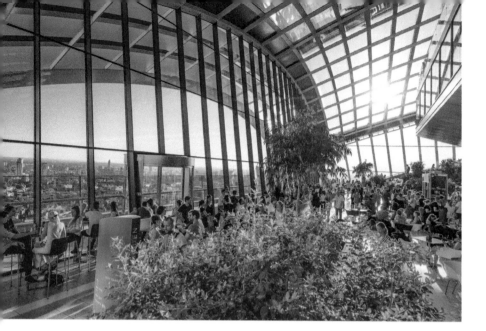

Sky Garden is London's highest public garden. Occupying the three-floor section at the top of the 20 Fenchurch Street "Walkie-Talkie" skyscraper, has views of ferns and skylines.

Obligated to be public, free access is limited to time-slots booked three days in advance.

✉ **Addr:**	20 Fenchurch St, London EC3M 8AF	♀ **Where:**	51.511042 -0.083362	
❓ **What:**	Garden	☾ **When:**	Indoors	
👁 **Look:**	West	W **Wik:**	20_Fenchurch_Street#Sky_garden	

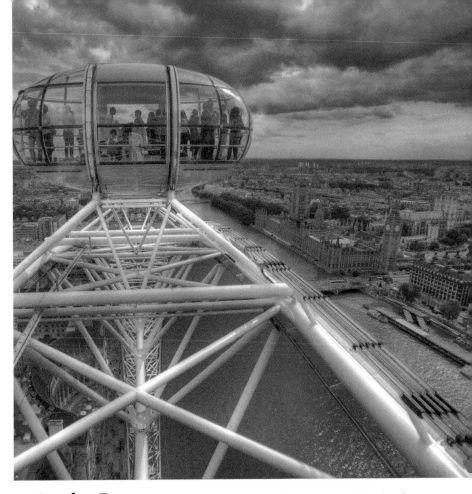

The **London Eye** opened in 2000 as the world's tallest Ferris wheel and is the most popular paid tourist attraction in the United Kingdom. The view from 443 feet (135 m) above the Thames includes the Houses of Parliament (above).

✉ **Addr:**	South Bank, London SE1 7PB	♥ **Where:**	51.503408 -0.119637
❓ **What:**	Ferris wheel	☽ **When:**	Morning
👁 **Look:**	South-southwest	W **Wik:**	London_Eye

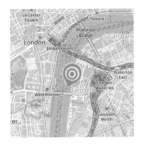

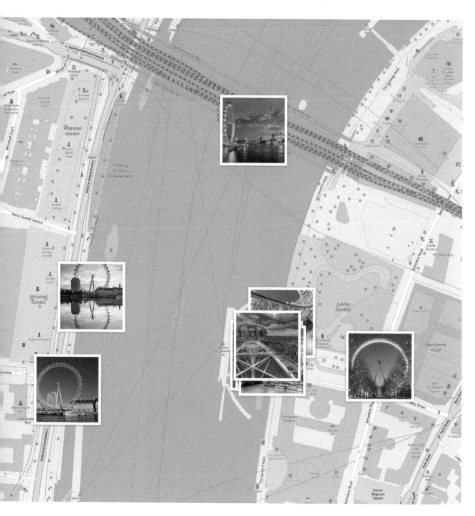

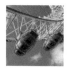
 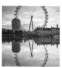 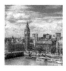
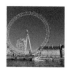
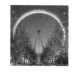

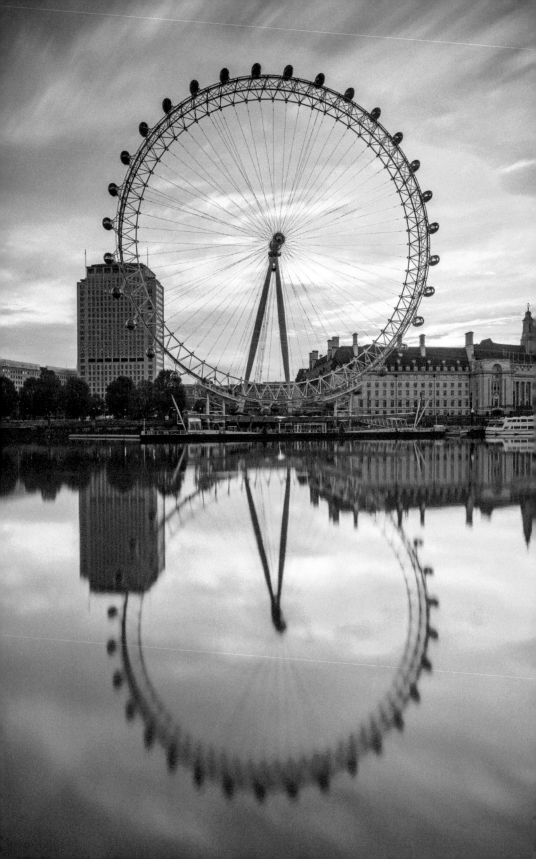

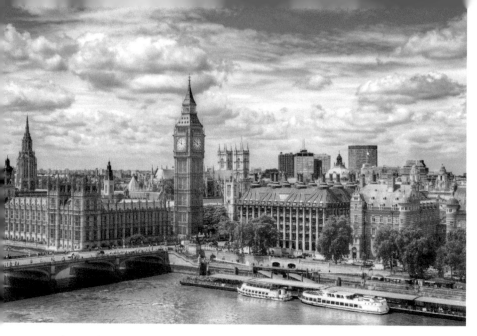

Above: The Eye moves slow enough for you to take many bird's eye photos.

 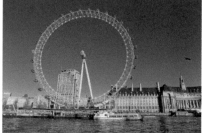

Below: An avenue of trees leading to the entrance from Belvedere Road.

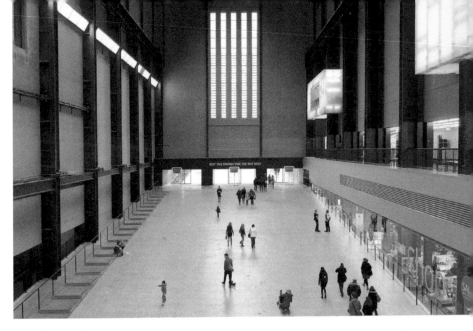

The **Tate Modern** is the world's most-visited modern art gallery. The massive Turbine Hall (above) was part of the Bankside Power Station.

On the southwest corner is the ten-story Blavatnik Building (bottom-left), which has a viewing area on the top level (bottom-right).

✉ **Addr:**	Bankside, London SE1 9TG	♀ **Where:**	51.507537 -0.099016	
❓ **What:**	Museum	☽ **When:**	Indoors	
👁 **Look:**	West	W **Wik:**	Tate_Modern	

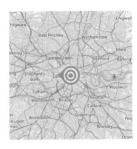 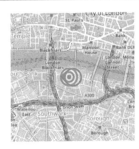

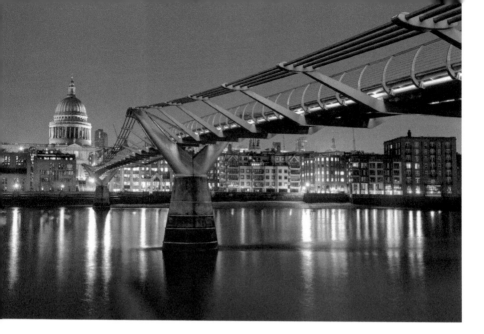

Millennium Bridge is a steel suspension footbridge aligned for a clear view of St. Paul's Cathedral. The suspension cables are to the sides of the bridge, rather than overhead, producing a wide and low profile.

The bridge is best photographed from the South Bank by the Tate Modern, to include St. Paul's in the background.

✉ **Addr:**	Thames Embankment, London SE1 9JE	♀ **Where:**	51.508382 -0.09922	
❷ **What:**	Bridge	☾ **When:**	Afternoon	
👁 **Look:**	North-northeast	W **Wik:**	Millennium_Bridge,_London	

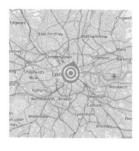 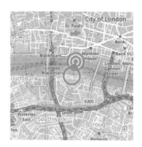

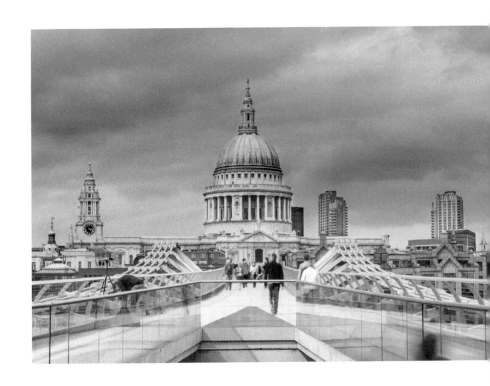

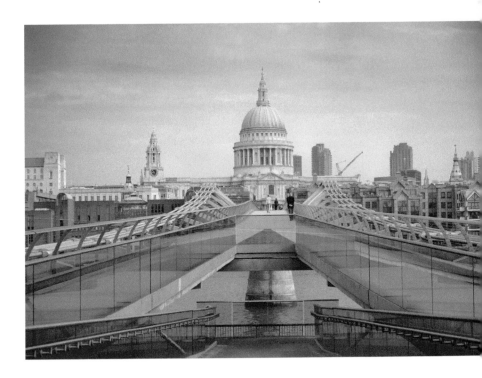

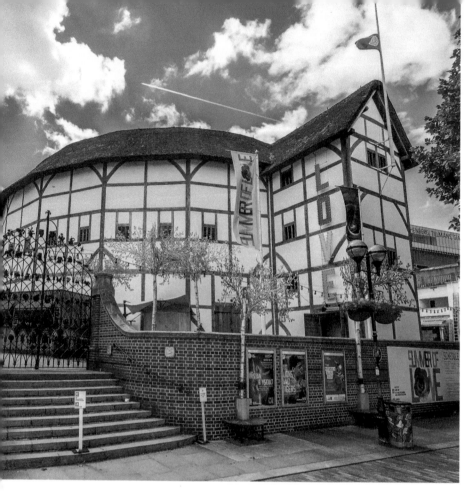

Shakespeare's Globe is a reconstruction of the Bard's theater-in-the-round, originally built in 1599. The Globe is located by the Tate Modern, and this view is from Queen's Walk along the Thames. A paid guided tour takes you to the balconies and backstage (right).

✉ **Addr:**	21 New Globe Walk, London SE1 9DT	♀ **Where:**	51.50838 -0.096782
❔ **What:**	Theater	☽ **When:**	Morning
👁 **Look:**	Southwest	W **Wik:**	Shakespeare%27s_Globe

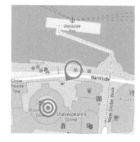

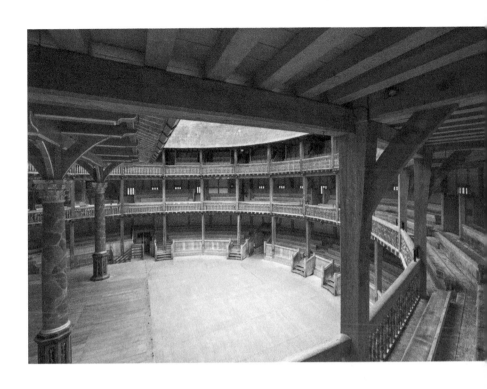

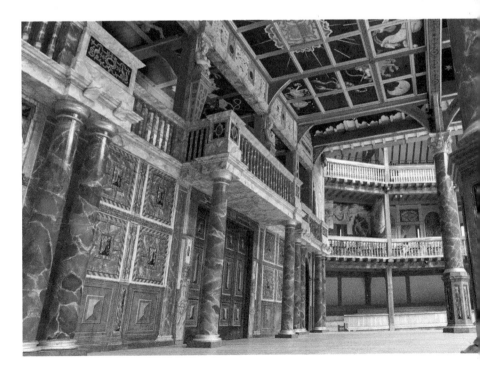

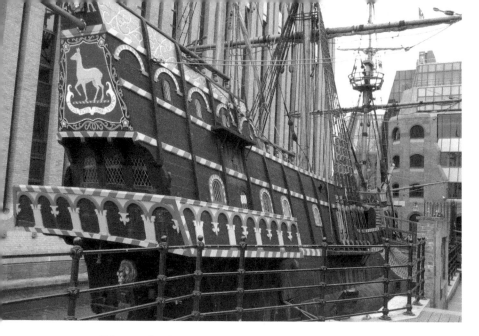

The **Golden Hinde** is a replica of the first ship to circumnavigate of the globe. Built with traditional methods in Devon and launched in 1973, the full-size reconstruction is seaworthy and has herself circumnavigated the globe. Open to the public, she resides next to Old Thameside Inn at Bankside.

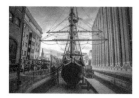

The original *Golden Hind* was named and captained by Sir Francis Drake on her three-year journey (1577–1580). Raiding a Spanish galleon en route, the ship returned to Plymouth with enough treasure to pay off the entire government debt, twice over.

✉ **Addr:**	St Mary Overie's Dock, London SE1 9DE	♀ **Where:**	51.50709 -0.090315
❓ **What:**	Ship	◑ **When:**	Afternoon
👁 **Look:**	South	W **Wik:**	Golden_Hinde_(1973)

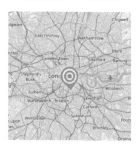
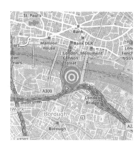

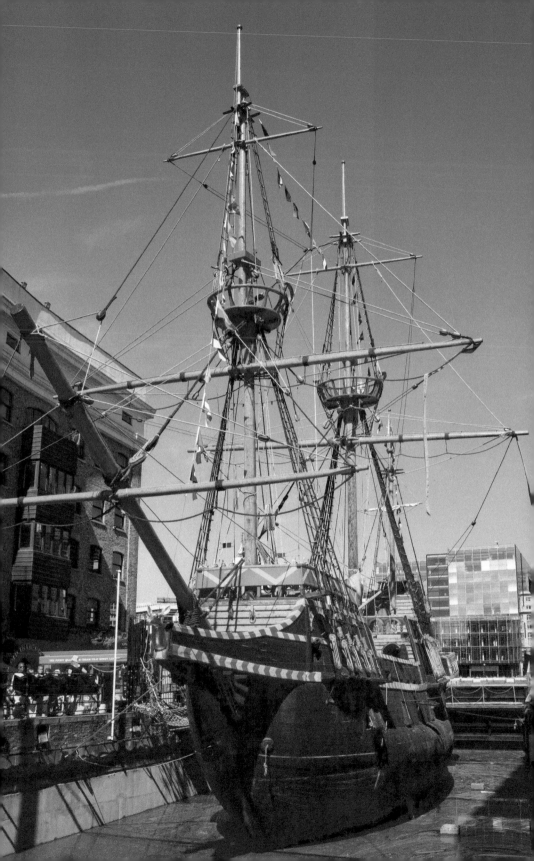

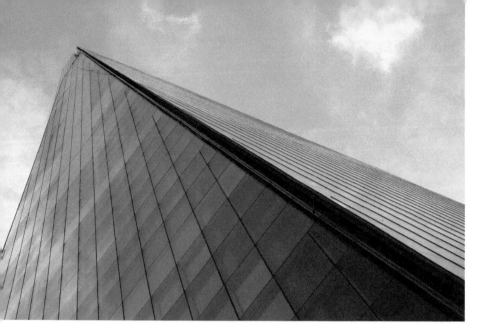

The Shard dominates the London skyline and is Europe's tallest building. Standing 1,016 feet (310 m) high, the 2012 skyscraper was designed by Renzo Piano. There is an observation deck [paid admission] called The View (below).

✉ **Addr:**	32 London Bridge St, London SE1 9SG	♀ **Where:**	51.504068 -0.08652
❓ **What:**	Building	☾ **When:**	Morning
👁 **Look:**	North-northwest	Ⓦ **Wik:**	The_Shard

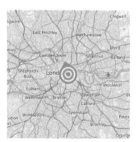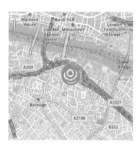

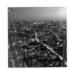 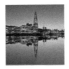 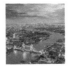

 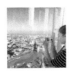 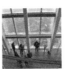

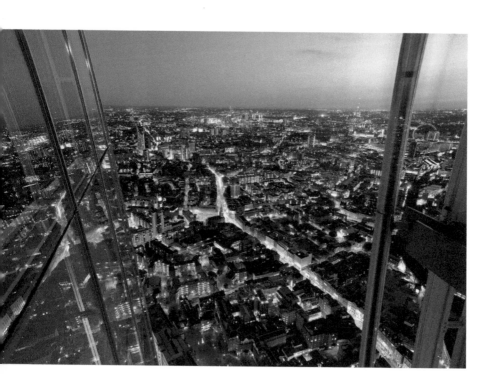

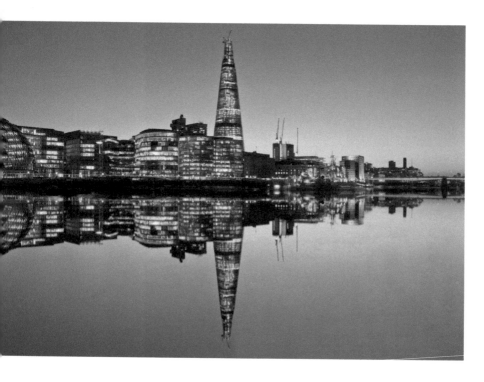

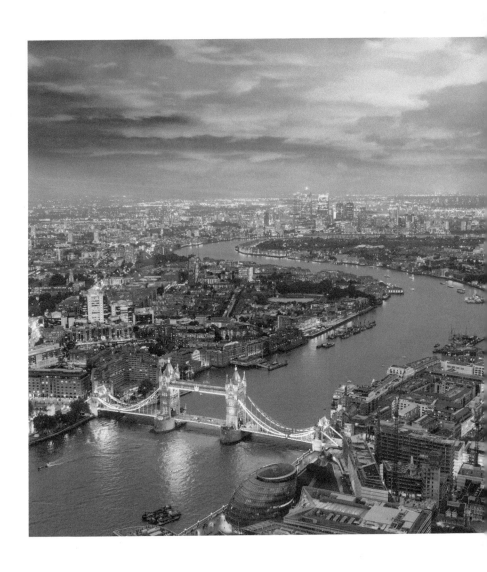

South Bank > London Borough of Southwark > Bankside > The Shard

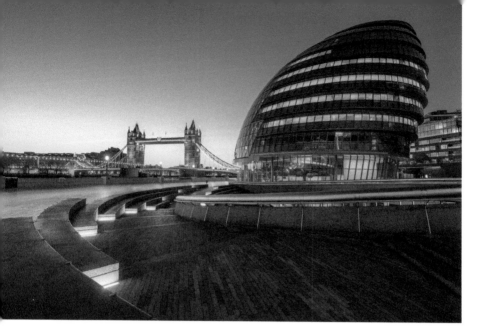

London City Hall is housed in a 2002 slanted orb by Norman Foster. A helical walkway (below left) ascends the full ten stories and leads to an open viewing deck which is occasionally open to the public (below right).

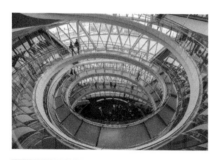
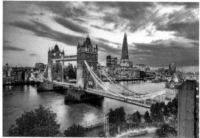

🖂 **Addr:**	The Queen's Walk, London SE1 2AA	♀ **Where:**	51.505033 -0.079576	
❓ **What:**	City	🕐 **When:**	Afternoon	
👁 **Look:**	East-southeast	Ⓦ **Wik:**	City_Hall,_London	

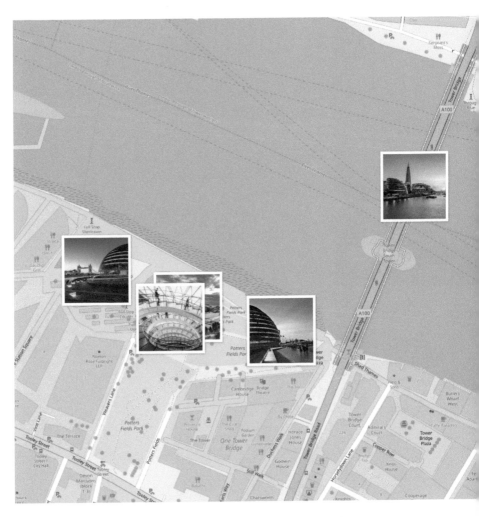
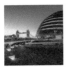

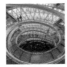

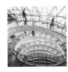

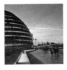

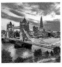
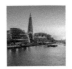

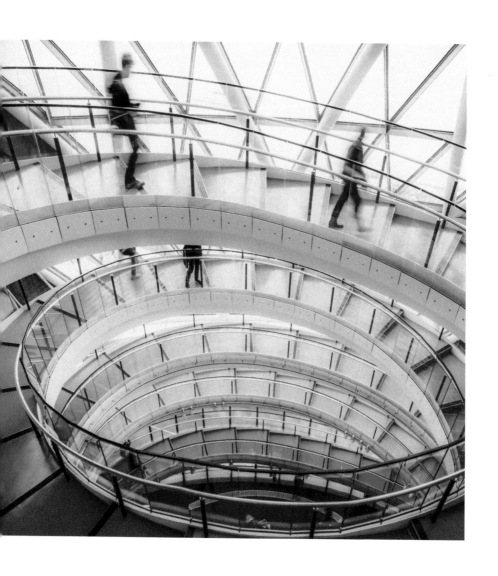

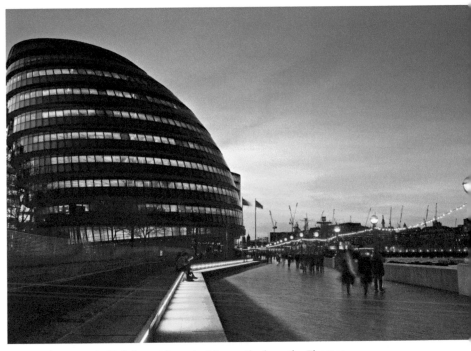

Above: The Queen's Walk is a wide pedestrian path along the Thames.
Below: The view from Tower Bridge at sunset includes London City Hall and The Shard.

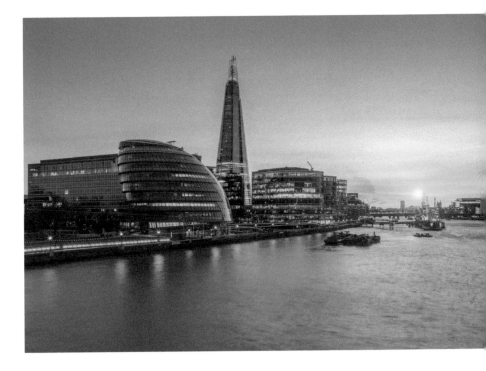

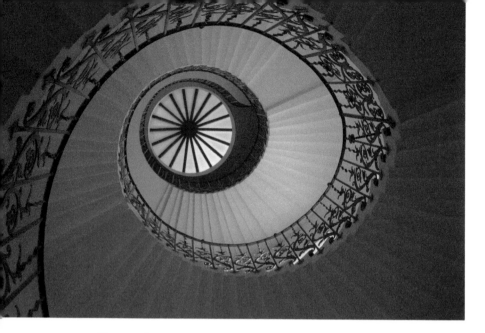

The **Tulip Stairs** at the Queen's House provide a beautiful abstract photograph around a lantern (skylight). Built 1616–1635 with cantilever support from the walls, these were the first helical stairs in England without a central support.

The Tulip Stairs are in the Queen's House, a former royal residence in Greenwich and the first consciously classical building in the country. Architect Inigo Jones had just returned from a grand tour of Roman, Renaissance, and Palladian architecture in Italy and used his inspiration to great effect. The inspiration for classical English and American Palladianism can be traced to this building.

Spiral staircases make great photography subjects as they are full of leading lines provide motion for the eye and show depth.

✉ **Addr:**	Queen's House, London SE10 9NF	♈ **Where:**	51.481258 -0.0036621	
❓ **What:**	Helical stairs	⏱ **When:**	Indoors	
👁 **Look:**	Up	Ⓦ **Wik:**	Queen%27s_House	

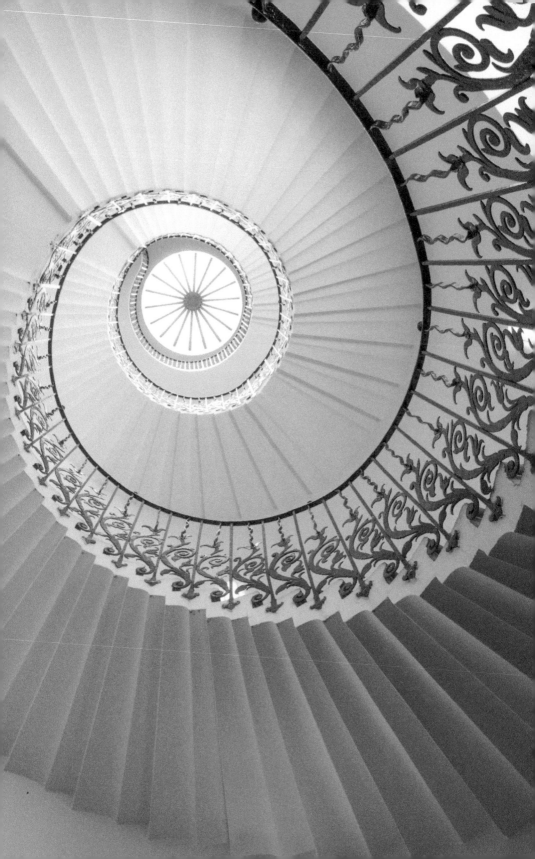

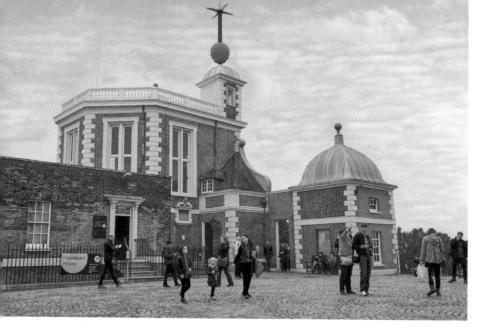

The **Royal Observatory, Greenwich** played a major role in global navigation and is the historical home of the prime meridian (0° longitude). Greenwich Mean Time (GMT) is measured from here, as the average (mean) moment the sun crosses the observatory and reaches its highest point in the sky.

Built in 1676, the Royal Observatory was commissioned by King Charles II to "...to find out the so much desired longitude of places for the perfecting of the art of navigation." The 20 foot high Octagon Room (above) housed two clocks with 13 foot (4 m) long pendulums above the clock face — the most accurate of the day.

A red time ball was added in 1833 to help mariners at the port to synchronize their clocks to GMT. Every day, as a time signal, the ball is dropped at 1pm.

✉ **Addr:**	Blackheath Ave, London SE10 8XJ	📍 **Where:**	51.477947 -0.001542	
❓ **What:**	Observatory	☾ **When:**	Afternoon	
👁 **Look:**	South-southeast	W **Wik:**	Royal_Observatory,_Greenwich	

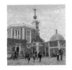

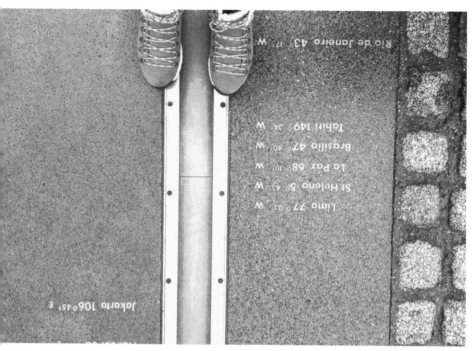

Above: Standing over the original prime meridian.
Below: The Dolphin Sundial (1978 by Christopher Daniel and Edwin Russell) tells the time using the gap between the two tails as the gnomon (pointer).

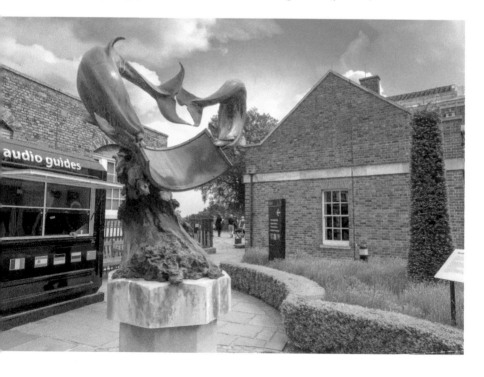

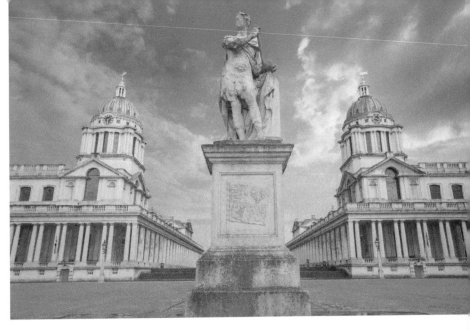

Old Royal Naval College is Sir Christopher Wren's twin-domed riverside masterpiece. Built 1696–1712 as a naval hospital, the symmetrical complex has an avenue in the center due to a requirement of Mary II: that the Queen's House to the southeast retained a view of the Thames.

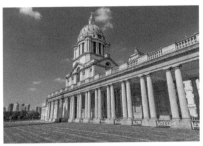 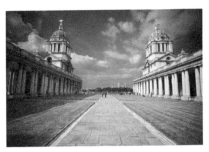

✉ **Addr:**	King William Walk, London SE10 9NN	♥ **Where:**	51.4837692 -0.0059873
❓ **What:**	College	☽ **When:**	Afternoon
👁 **Look:**	South-southeast	W **Wik:**	Old_Royal_Naval_College

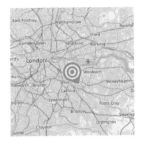 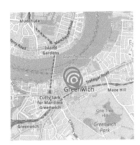

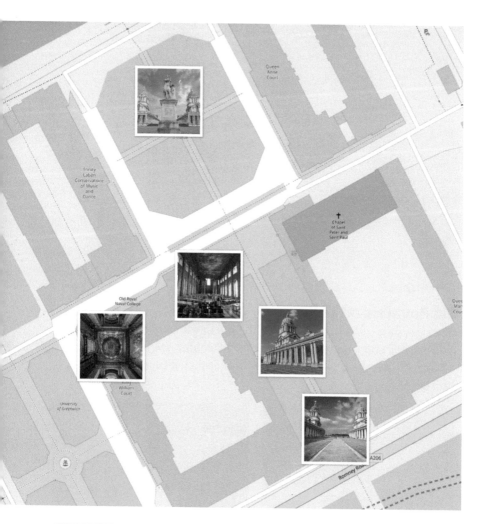

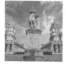 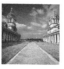

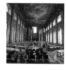

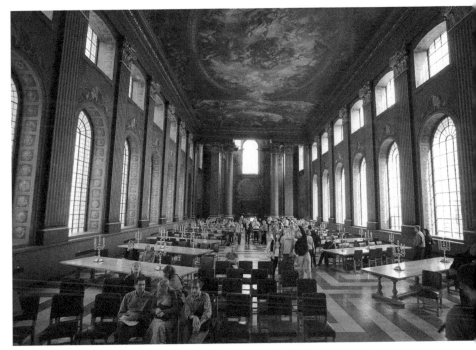

The Painted Hall (above) was painted between 1707 and 1726 by Sir James Thornhill. Its entrance hall (vestibule, below) is beneath the west dome.

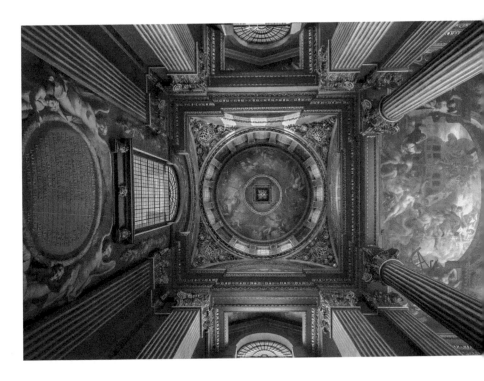

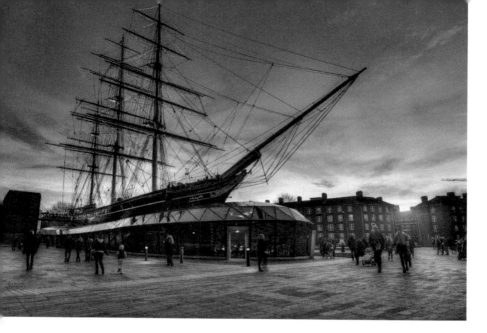

Cutty Sark is one of the fastest — and last — tea clipper ships. Built in 1869, she sailed eight times from China to England, with a fastest time of 107 days. She is on display in Greenwich at a dry dock, where a glass-roofed building (fee required) allows you to walk under and around her keel (right).

This high impact perspective is courtesy of a wide-angle lens. My favorite length is a 28mm lens (or the equivalent on a non-35mm camera). To get both the foreground and background in focus (called a "wide depth-of-field") you'll need a small aperture (with a big "f" number, such as f/22).

✉ **Addr:**	King William Walk, London SE10 9HT	♀ **Where:**	51.4833752 -0.00959	
❓ **What:**	Ship	☽ **When:**	Sunset	
👁 **Look:**	South	W **Wik:**	Cutty_Sark	

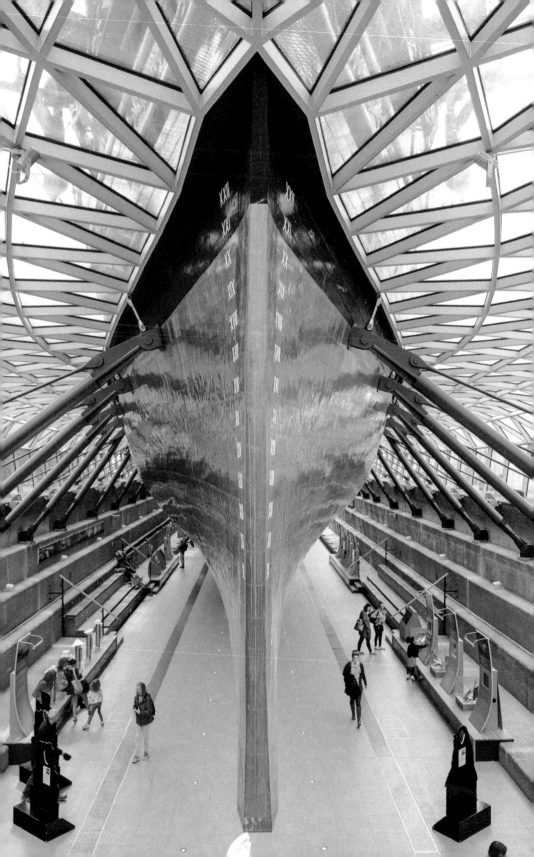

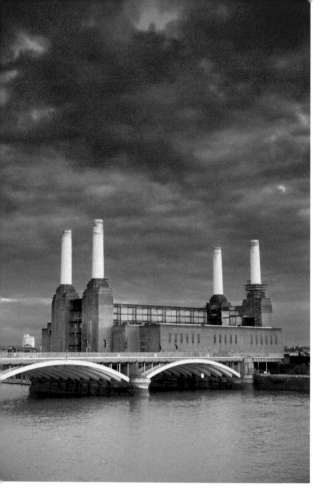

Battersea Power Station is a decommissioned coal-fired power station located on the south bank of the River Thames. This view is from the north end of Chelsea Bridge. A similar view (but from the southeast) was famously used on the cover of Pink Floyd's 1977 album, *Animals*, along with, of course, a floating pink pig.

✉ **Addr:**	Battersea Power Station, London SW8	♀ **Where:**	51.485477 -0.149831	
❓ **What:**	Building	☽ **When:**	Afternoon	
👁 **Look:**	Southeast	W **Wik:**	Battersea_Power_Station	

Out of Order is an unusual sculpture of a dozen telephone boxes falling like dominoes. Created by Scottish sculptor and installation artist David Mach in 1988, the artwork lies by the Wilko store in Kingston upon Thames, 10 miles (16 km) southwest of Big Ben.

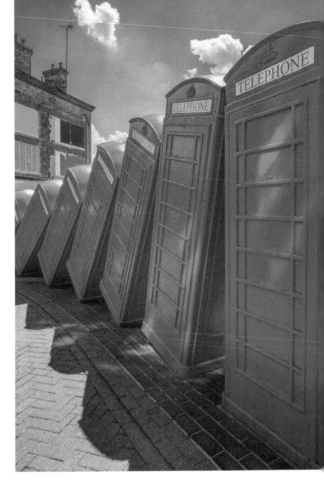

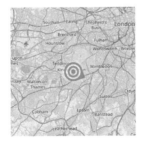

✉ **Addr:**	29a Old London Rd, Kingston upon Thames KT1 1QT	♀ **Where:**	51.410839 -0.300603
❓ **What:**	Sculpture	◑ **When:**	Afternoon
👁 **Look:**	East-southeast	↔ **Far:**	11 m (36 feet)

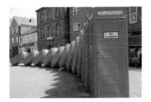

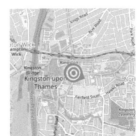

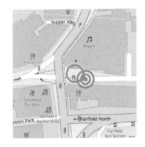

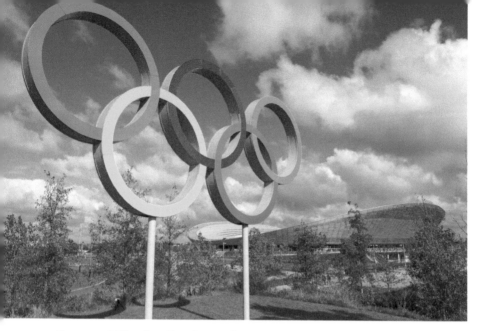

Queen Elizabeth Olympic Park is the site of the 2012 Olympic Games and includes three photogenic elements from the event.

The **Olympic Rings** (above) are located on a small hill along the main approach pedestrian path. This view from the south side includes the **Velodrome** in the background.

ArcelorMittal Orbit is Britain's largest piece of public art. The Olympic tower is a sculpture and observation tower, 376 feet (114 m) tall. Funded mainly by steel tycoon Lakshmi Mittal of ArcelorMittal, the *Orbit* was designed by Sir Anish Kapoor and Cecil Balmond.

✉ **Addr:**	Olympic Park, London E15 2GY	♀ **Where:**	51.548812 -0.01663
❓ **What:**	Park	☾ **When:**	Afternoon
👁 **Look:**	North-northeast	𝕎 **Wik:**	Olympic_Park,_London

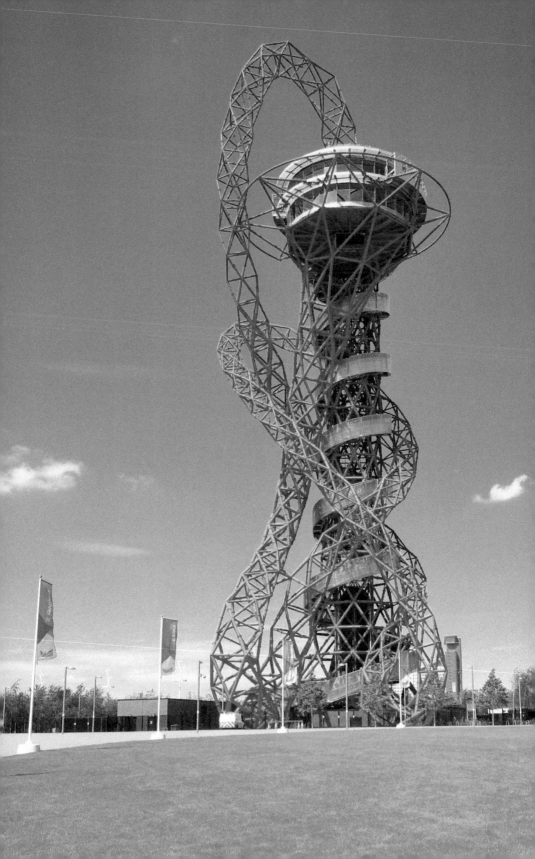

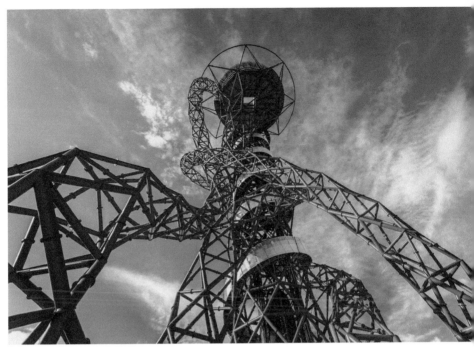

The ArcelorMittal Orbit (above) and Velodrome (below).

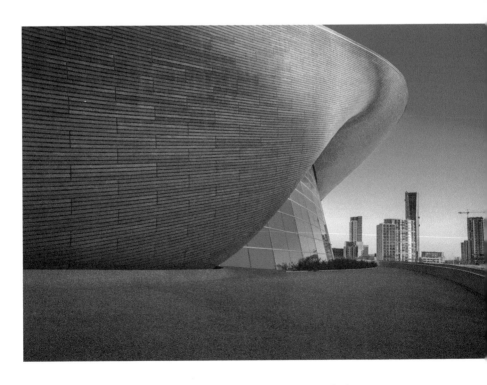

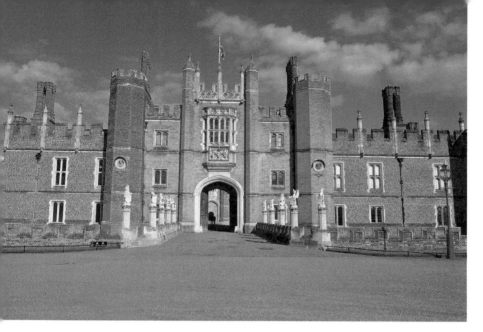

Hampton Court Palace is Henry VIII's 16th century masterpiece, his favorite palace and residence to many of his queens. Cardinal Thomas Wolsey commenced construction in 1515, but, to reduce his fall from favor, gifted the palace to the King in 1529.

The Great Gatehouse (above) combines perpendicular Gothic-inspired Tudor with restrained Renaissance ornament. The bridge over the moat features heraldic animals (right), called the King's Beasts.

Hampton Court Palace is located 12 miles (19 km) southwest of central London in Richmond upon Thames, easily reached by train from Waterloo station. Paid admission.

✉ **Addr:**	Molesey, East Molesey KT8 9AU	♀ **Where:**	51.403576 -0.339739
❷ **What:**	Former royal palace	☾ **When:**	Afternoon
👁 **Look:**	East	Ⓦ **Wik:**	Hampton_Court_Palace

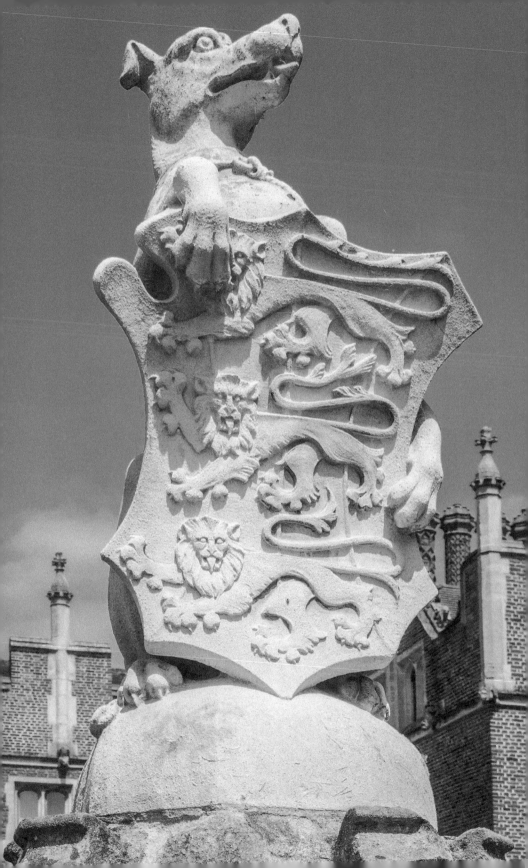

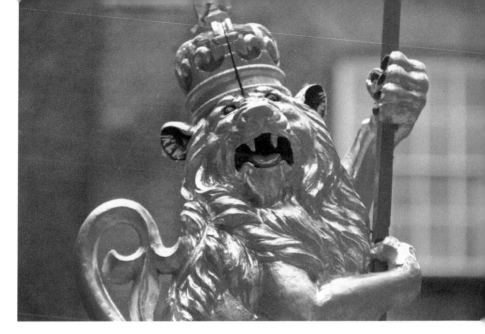

Above: A royal lion in the Chapel Court Garden.

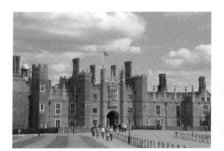

Below: Christopher Wren's south front and the Privy Garden.

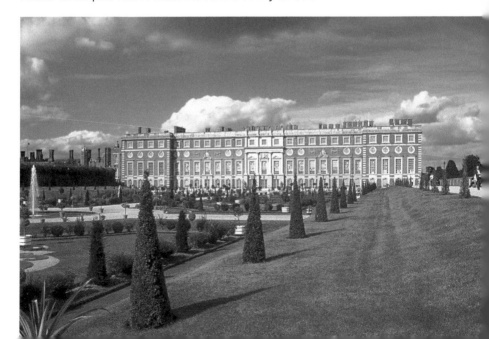

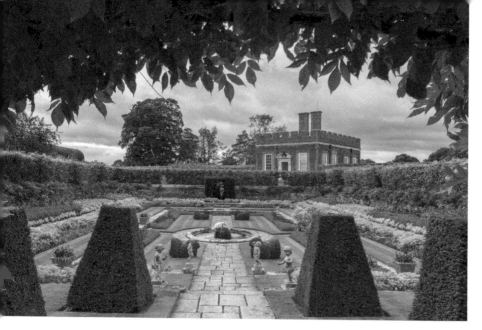

Above: A sunken garden and the Banqueting House. Below: The Chapel.

Below: Anne Boleyn's Gate viewed from the Great Gatehouse.

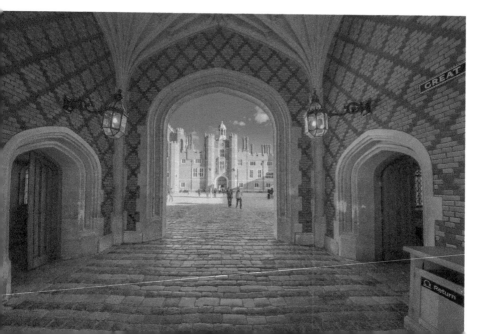

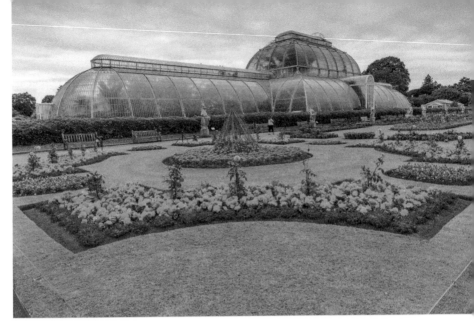

Kew Gardens is a famous botanic garden with the largest and most diverse botanical and mycological collections in the world. Created in 1759 and officially known as Royal Botanic Gardens, Kew, the 300 acre (121 hectares) site is in Richmond, 5.6 miles (9 km) northeast of Hampton Court Palace.

The **Palm House** (above) was built 1844–48 with a space frame of wrought iron arches and glass panels. On the east side are the Queen's Beasts (ten statues of animals bearing shields) and a formal garden (pareterre).

Another photogenic wonder is **The Hive** (2015, Wolfgang Buttress). A 56-foot (17 m) tall enclosure provides an immersive experience with lights and sound inspired by bees.

✉ **Addr:**	Kew Rd, Richmond TW9 3AB	♀ **Where:**	51.478633 -0.291757
❓ What:	Gardens	⏱ **When:**	Morning
👁 **Look:**	Northwest	Ⓦ **Wik:**	Kew_Gardens

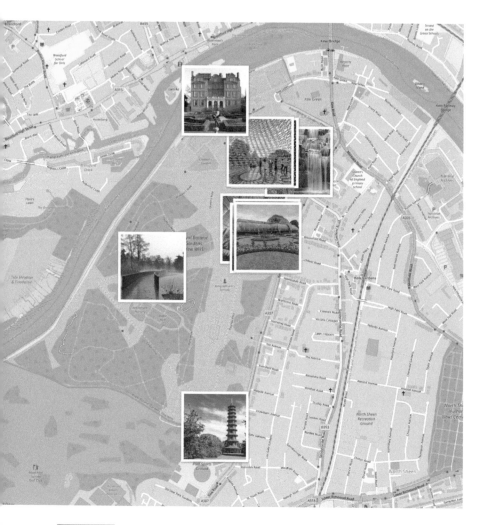

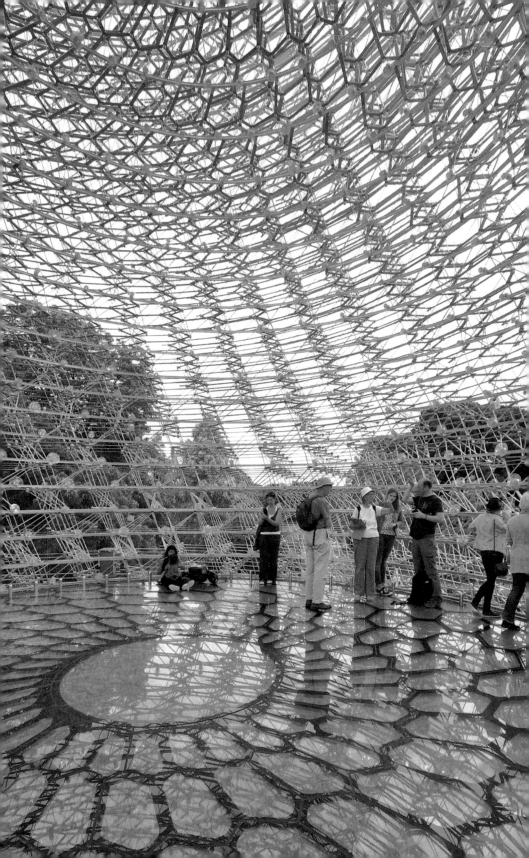

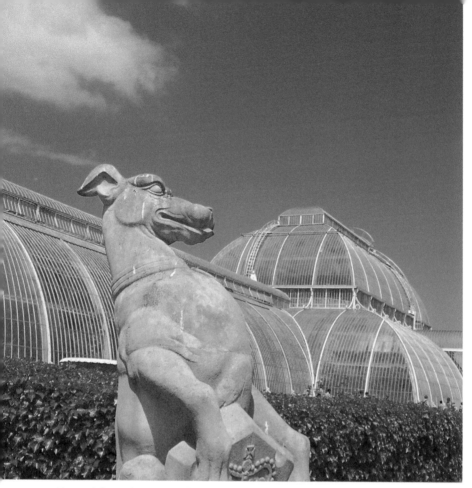

Above: A Queen's Beast. Below: The Sackler Crossing.

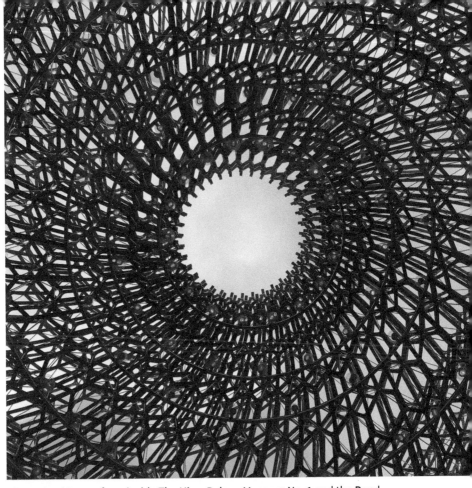

Above: Looking up from inside The Hive. Below: Museum No. 1 and the Pond.

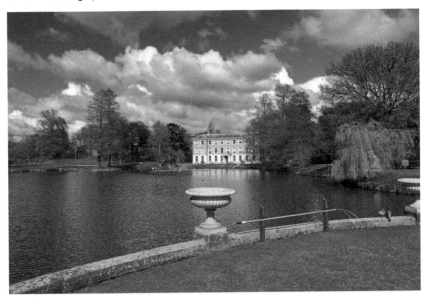

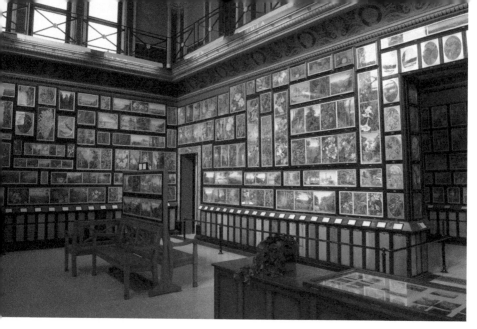

Above: The Marianne North Gallery. Below: The Queen's Garden.

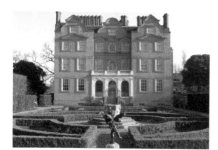
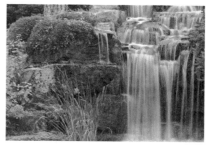

Below: The Great Pagoda by the Japanese Landscape.

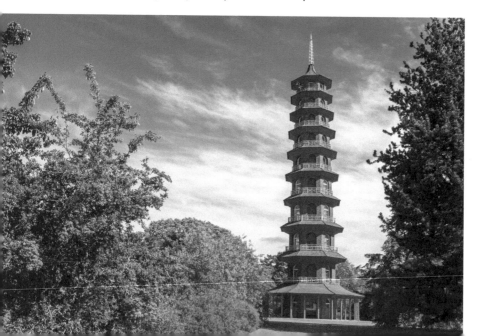

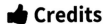 Credits

Thank you to the many wonderful people and companies that made their work available to use in this guide.

Photo key: The number is the page number. The letters reference the position on the page, the distributor and the license. Key: a:CC-BY-SA; b:bottom; c:center; f:Flickr; h:Shutterstock standard license; l:public domain; o:CC0; q:Pixabay; s:Shutterstock; t:top; w:Wikipedia; y:CC-BY.

Cover image by Double Bind/Shutterstock. Back cover image by Aslysun/Shutterstock. Other images by: A.canvas.of.light (101 sh); Alice-photo (25, 54t, 104 sh); Amadeustx (102 sh); Andersphoto (63 sh); Androniques (164b sh); Leonid Andronov (43, 43 sh); Ansharphoto (26t sh); Anton_ivanov (105t sh); Anyaivanova (50t sh); Doug Armand (138c sh); Asiastock (70, 118, 145, 160b sh); Aslysun (30 sh); Tony Baggett (25b, 131 sh); Baloncici (75t sh); Willy Barton (58t, 58, 72, 81, 82, 82, 99, 102 sh); Bba Photography (151t, 155b sh); Bcfc (115 sh); Photocreo Michal Bednarek (124t sh); Christian Bertrand (55 sh); Bikeworldtravel (65, 125 sh); Double Bind (87 sh); Justin Black (86t, 89t wy); Stephen Boisvert (164t sh); S Borisov (127t sh); Sarah Bray (67 sh); Chrisdorney (44t, 74t, 106t sh); Christo Mitkov Christov (60 fa); Colin (136 sh); Cowardlion (80, 82t, 144b, 145t sh); Philip Bird Lrps Cpagb (75b, 124 sh); Daliu (27, 29 sh); Chris Dalton (117 wa); Diego Delso (24 sh); Songquan Deng (127b, 150t wa); Diliff (53t sh); Angelina Dimitrova (91 sh); Claudio Divizia (68, 69, 76, 128t sh); Dreamcatcherdiana (93b sh); Elenachaykinaphotography (94t, 95, 97t sh); Elena Elisseeva (139t sh); Ron Ellis (102t, 119t, 153, 163 sh); Elroce (101b sh); Eqroy (62 fy); Martin Alvarez Espinar (68t sh); Exflow (101t sh); F11photo (34c, 47 sh); Alexey Fedorenko (60 sh); Fenlioq (20t sh); Angelo Ferraris (124 wa); Fiatlux (43 wy); Eg Focus (132 sh); Prochasson Frederic (139b sh); Giovanni G (76t sh); Gagliardiphotography (32t, 119 sh); Gimas (129t, 129b sh); Lois Gobe (78t qo); Illusions Of Grandeur (165b sh); Grzegorz_pakula (45 sh); Sven Hansche (33 sh); I Wei Huang (39t sh); Alex Hubenov (166 fy); Bill Hunt (145, 147t sh); Victor Iemma (144t sh); Ilongloveking (161t sh); Vicky Jirayu (151 fa); Jpitha (43 fy); Steve Jurvetson (121t sh); K065167 (85 sh); Agatha Kadar (78, 79 sh); Kamira (35t fa); Prasad Kholkute (25t sh); Kiev.victor (43, 43, 157 sh); Masami Kihara (70t sh); A And J King (132t sh); Patryk Kosmider (47 sh); Liudmila Kotvitckaia (47t sh); Lazyllama (152t sh); Aija Lehtonen (125t sh); Ioannis Liasidis (114b, 148t sh); Felix Lipov (26 sh); Lterlecka (66t sh); Luciano Mortula - Lgm (113b fy); Maciek Lulko (147b sh); Lunamarina (51 sh); Mapics (25 sh); Maridav (132 wa); Jose L Marin (130t sh); Marius_comanescu (130 sh); Rob Marmion (136 sh); Maziarz (29t, 38b wa); Mcginnly (140t sh); Mikecphoto (116 sh); Mistervlad (67t, 156t sh); Luciano Mortula (91b wa); Mrsellacott (160t sh); Christian Mueller (56t, 57 sh); Casa Nayafana (80t sh); Andrei Nekrassov (23t, 53 sh); Niepo (134t fy); Laura Nolte (166 sh); Noyanyalcin (125 sh); Nui7711 (149 fy); Stig Nygaard (62t sh); Olavs (90t sh); Lukasz Pajor (38t, 56, 91t, 123, 136t sh); Pres Panayotov (148 sh); Paolo Paradiso (70 wl); Patche99z (166t sh); Pajor Pawel (114t, 120t sh); Gary Perkin (142t sh); Mach Photos (72t, 73 sh); Vdb Photos (89b sh); Photo.ua (21 sh); Pio3 (81t sh); Pisaphotography (93t, 135c sh); Pj_photography (155t wl); Andreas Praefcke (105 sh); Prettyawesome (64t sh); Gts Productions (76 sh); Qq7 (111, 118t wa); Redcoat (53 sh); Rihardzz (23 sh); Rika-sama (113t sh); R.nagy (53b sh); Roberto La Rosa (97b sh); Andreas Rose (41 sh); Alexandre Rotenberg (59t, 107t sh); S-f (66 sh); S4svisuals (32b, 39b fy); Sagesolar (101 sh); S.borisov (35b sh); Seancooneyfoto (40t sh); Alex Segre (108 sh); Fedor Selivanov (49 fy); Francesco Sgroi (91 sh); Skyearth (110t, 134b sh); Archer All Square (109t sh); Petru Stan (120 sh); David Steele (43t wy); Stephantom (98 sh); Boris Stroujko (60t sh); Teerinvata (83 wa); Andreas Tille (159b sh); Pitcha Torranin (124b fa); Traveljunction (159t, 159 sh); Anibal Trejo (43b sh); Justyna Troc (141 sh); Ttstudio (126t sh); Tupungato (108t sh); Yuri Turkov (47b wy); Tuuraan78 (98t sh); Ints Vikmanis (48t sh); Ewelina

Wachala (36t sh); Walter_g (160c fy); William Warby (159 sh); Cedric Weber (116t sh); Warundhorn Weerasaktara (165t sh); Zgphotography (23b, 114c sh).

Some text adapted from Wikipedia and its contributors, used and modified under Creative Commons Attribution-ShareAlike (CC-BY-SA) license. Map data from OpenStreetMap and its contributors, used under the Open Data Commons Open Database License (ODbL).

This book would not exist without the love and contribution of my wonderful wife, Jennie. Thank you for all your ideas, support and sacrifice to make this a reality. Hello to our terrific kids, Redford and Roxy.

Thanks to the many people who have helped PhotoSecrets along the way, including: Bob Krist, who answered a cold call and wrote the perfect foreword before, with his wife Peggy, becoming good friends; Barry Kohn, my tax accountant; SM Jang and Jay Koo at Doosan, my first printer; Greg Lee at Imago, printer of my coffe-table books; contributors to PHP, WordPress and Stack Exchange; mentors at SCORE San Diego; Janara Bahramzi at USE Credit Union; my bruver Pat and his family Emily, Logan, Jake and Cerys in St. Austell, Cornwall; family and friends in Redditch, Cornwall, Oxford, Bristol, Coventry, Manchester, London, Philadelphia and San Diego.

Thanks to everyone at distributor National Book Network (NBN) for always being enthusiastic, encouraging and professional, including: Jed Lyons, Jason Brockwell, Kalen Landow (marketing guru), Spencer Gale (sales king), Vicki Funk, Karen Mattscheck, Kathy Stine, Mary Lou Black, Omuni Barnes, Ed Lyons, Sheila Burnett, Max Phelps, Jeremy Ghoslin and Les Petriw. A special remembrance thanks to Miriam Bass who took the time to visit and sign me to NBN mainly on belief.

The biggest credit goes to you, the reader. Thank you for (hopefully) buying this book and allowing me to do this fun work. I hope you take lots of great photos!

© Copyright

PhotoSecrets London, first published November 23, 2019. This version output October 6, 2019.

ISBN: 978-1930495647. Distributed by National Book Network. To order, call 800-462-6420 or email customercare@nbnbooks.com.

Curated, designed, coded and published by Andrew Hudson. Copyright © 2019 Andrew Hudson/PhotoSecrets, Inc. Copyrights for the photos, maps and text are listed in the credits section. PHOTOSECRETS and the camera-map-marker icon are registered trademarks of PhotoSecrets.

> *"'And what is the use of a book,' thought Alice*
> *'without pictures or conversations?'"*
> *— Alice's Adventures in Wonderland, Lewis Carroll*

© Copyright

✎ Disclaimer

The information provided within this book is for general informational purposes only. Some information may be inadvertently incorrect, or may be incorrect in the source material, or may have changed since publication, this includes GPS coordinates, addresses, descriptions and photo credits. Use with caution. Do not photograph from roads or other dangerous places or when trespassing, even if GPS coordinates and/or maps indicate so; beware of moving vehicles; obey laws. There are no representations about the completeness or accuracy of any information contained herein. Any use of this book is at your own risk. Enjoy!

✉ Contact

For corrections, please send an email to andrew@photosecrets.com. Instagram: photosecretsguides; Web: www.photosecrets.com

■■ Index

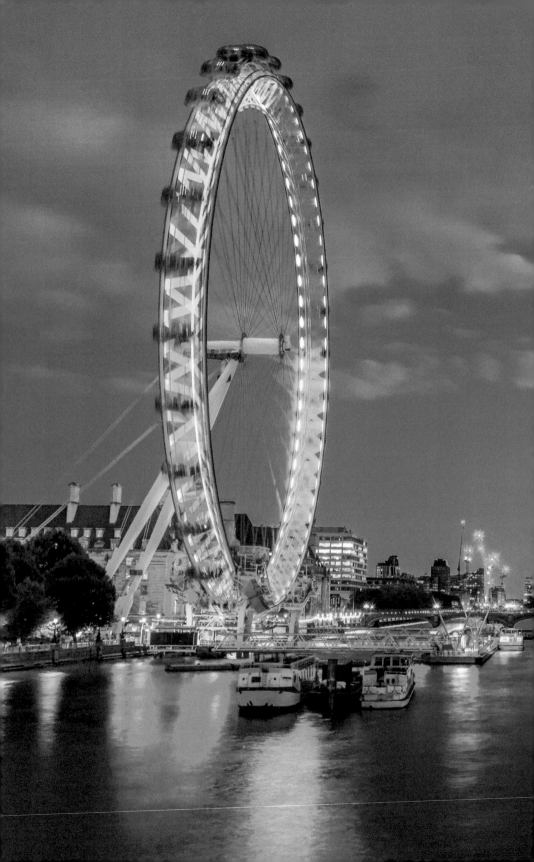

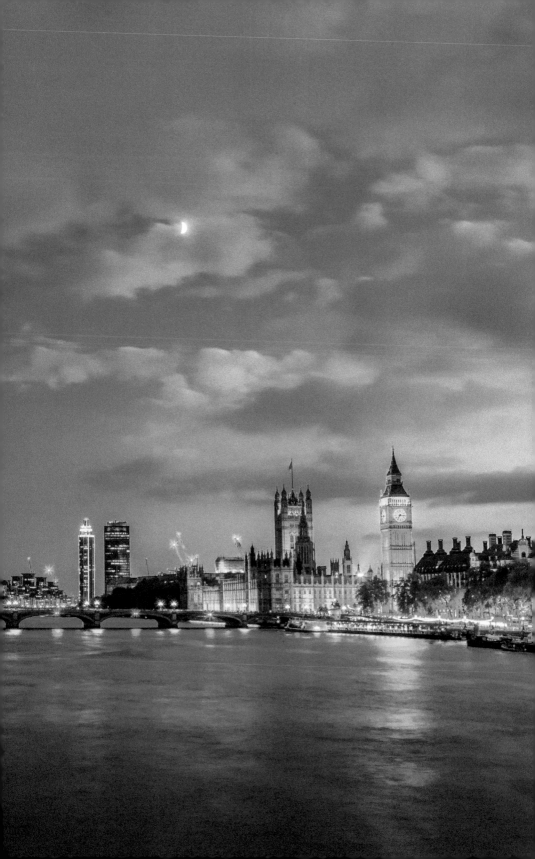

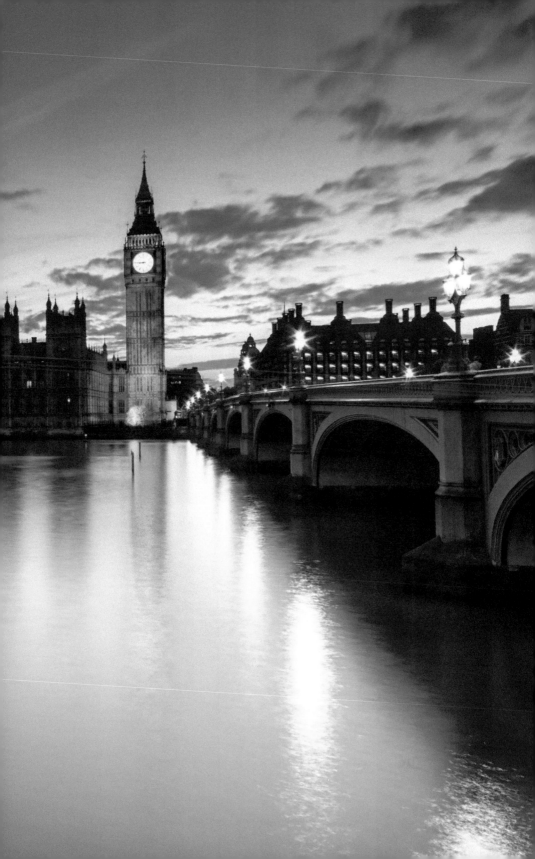

👍 More guides from PhotoSecrets